LYNN BOGUE HUNT

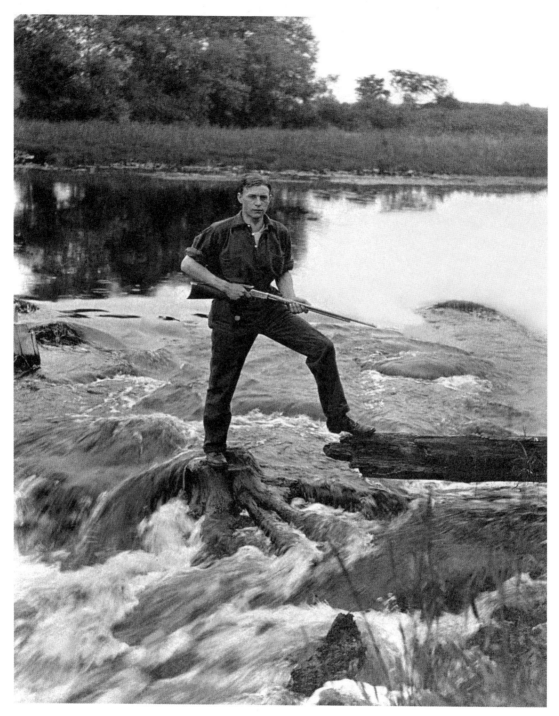

Hunt at St. Claire Shores, Michigan at about the age of 20. Photo courtesy of Jane Marie Gaines

LYNN BOGUE HUNT

A Sporting Life

Kevin C. Shelly

Edited by M. L. Biscotti

THE DERRYDALE PRESS

LANHAM AND NEW YORK

THE DERRYDALE PRESS

Published in the United States of America by
The Derrydale Press
A Member of the Rowman & Littlefield Publishing Group
4501 Forbes Blvd., Suite 200, Lanham, Maryland 20706

Distributed by NATIONAL BOOK NETWORK, INC.

First Derrydale Edition 2003
Copyright © 2003 by Kevin C. Shelly
Chapter opening sketches supplied courtesy of Ron McGrath

Library of Congress Cataloging-in-Publication Data

Shelly, Kevin C.
 Lynn Bogue Hunt : a sporting life / Kevin C. Shelly ; edited by M. L.
Biscotti.—1st Derrydale ed.
 p. cm.
Includes bibliographical references and index.
 ISBN 1-58667-075-1 (alk. paper); ISBN 1-56416-205-2 (deluxe)
 1. Hunt, Lynn Bogue—Criticism and interpretation. 2. Wildlife
art—United States. 3. Hunting in art. I. Hunt, Lynn Bogue. II.
Biscotti, M. L. III. Title.
 NC975.5.H86 S54 2003
 741'.092—dc21

 2002153511

♾™ The paper used in this publication meets the minimum requirements
of American National Standard for Information Sciences—Permanence of
Paper for Printed Library Materials, ANSI/NISO Z39.48-1992.
Manufactured in the United States of America.

For my girls—Nora and Katie

Contents

Acknowledgments

My thanks to the many individuals and organizations that provided information about Lynn Bogue Hunt and his work. Details about the private man behind the easel did not come easily.

Hunt's family—direct and extended—helped greatly, particularly granddaughter Marilynn Hunt Guzelian and grandniece Anne Farley Gaines-Masak.

Other members of the family who assisted include Susan Elizabeth Gaines-Gatto, Jane Marie Gaines, Sally Cordelia Gaines Mosher, Doreen Hunt, Alan Bryan Hunt, Diane Hunt, Steve Scharboneau, Lynn Bogue Hunt III, Cordelia Farley Helms, Betty C. Farley, Michael Farley, and William Small.

The family of Hunt's good friend, artist Milton C. Weiler, provided invaluable assistance. A special thanks to Bud Weiler, Dale Weiler, and Lynn Campbell.

Others who assisted include editor Duke Biscotti; art collector Paul Vartanian; writer George Reiger, and his publisher, Silver Quill Press; Albion, Michigan historian Frank Passic; sporting book dealer Lou Razek; sporting art dealer Tim Melcher; sporting book dealer Carol Lueder; director of the Blauvelt Museum Maryjane Singer; sportsman Dick Howell; Priscilla Milliman, daughter of artist John Frost; East

Hampton, New York resident Harriet Peele; East Hampton historian Bruce Collins; sporting art dealer Russell A. Fink; author and art dealer Walt Read; artist Tom Rost; editor Hugh Grey; the late H. G. Tapply; writer Bill Tapply; Princeton University Library; Albion College; Albion municipal librarian Leslie Dick; the Cedar Grove, New Jersey library; the International Game Fishing Association; the John F. Kennedy Library; artist Chet Reneson; artist Brett Smith; the National Gallery of Art; Honeoye Falls historian Anne Bullock; Ronald McGrath; sporting book dealer Ken Callahan; and the Art Students League of New York.

I would also like to thank Shelly Spindel, George Reiger, Paul Vartanian, and Peter Winants for reviewing the manuscript in detail.

A special thanks to two friends: Vernon Ogrodnek and John Froonjian. Their assistance was vital.

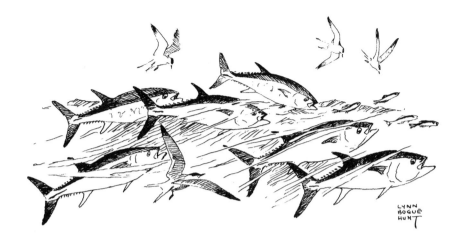

Foreword

GEORGE REIGER

Lynn Bogue Hunt's life coincided with a period in American history when the ordinary citizen's perception of nature evolved from fear through curiosity to pleasure. For more and more people, going into the Great Outdoors became an adventure, not adversity, recreation rather than hardship.

Wealthy men began taking trains and month-long vacations to far-flung corners of the continent to hunt and fish. At less affluent levels, workmen on trolleys and boys on bikes rode to the outskirts of towns and cities to find still-abundant fields and streams to explore with rod (or cane pole) and gun. Hunt lived when fewer than 100 million Americans inhabited a largely unpaved and unposted landscape—a country much different than today's where it is increasingly difficult to find roadless remnants that legally qualify as *wilderness*.

Hunt's illustrations inspire strong feelings of nostalgia, because they evoke a time when outdoor recreation was still *re-creation* and not yet measured in man-hours and bottom-lines. Hunt was not only an active participant in this Golden Age; he was also a pioneer of big-game angling. And for this reason alone, we should cut him some slack on his one tiny failing as a wildlife artist: he painted relatively few "wet fish."

(Most other wildlife illustrators can't paint "wet fish" either; only Stanley Meltzoff springs to mind as an exception.) Hunt's fish mostly resemble taxidermy mounts hung against appropriate backdrops. Even the cartoon swordfish he drew for Kip Farrington's *Bill—The Broadbill Swordfish* are as lively and real as the finished broadbill he painted for Charles L. Lehmann's chapter in *American Big Game Fishing*.

Yet when we see one of Hunt's successful fish—for example, the sailfish "tapping the bait off Miami Beach"—we also see the work of a man who knew and fished with Bill Hatch, the charter skipper who discovered the drop-back technique which made it possible for anglers to hook "tapping" sailfish. And just as we don't dwell on the limitations of artists who left us firsthand impressions of the American frontier, we overlook this one small flaw in Hunt's work, because it's enough that he left us a pictorial record of a world long since passed away.

Instead, let's focus on what Hunt did really well. And that's gamebirds—especially ducks. Even as sketches, they're full of life. But when integrated into an autumn marsh or over a winter bay, they're so real they quicken the pulse of any hunter who's been there.

Hunt must have loved waterfowl and waterfowling, for fully one-third of the more than one hundred covers he painted for *Field & Stream* over nearly half a century feature different species of ducks, geese and—twice—Chesapeake retrievers.

Another reason Hunt painted so many waterfowl is that *Field & Stream*'s owner and publisher, Eltinge F. Warner, was a passionate duck hunter. Each winter, he spent dozens of days in blinds or boats on New Jersey bays or Long Island ponds. During the decade of the Dust Bowl and Great Depression, Warner donated thousands of dollars to Ducks Unlimited to restore or create wetlands in the so-called duck factory of the Canadian prairies.

Lynn Bogue Hunt liked being in the company of such socially prominent people. Not only did *Field & Stream* seek out the best writers; its staff exuded sophistication. Eltinge Warner, for example, had introduced the tango to Paris with Irene Castle and hired George Jean Nathan (who in turn hired H. L. Mencken) to edit another of Warner's magazines (*Smart Set*), because Warner liked the cut of the clothes Nathan wore when they met on an ocean liner crossing the Atlantic.

Although first published in Minnesota, *Field & Stream* soon moved to the richer advertising pastures of Manhattan. There it acquired what angling editor A. J. McClane later called a "continental flair" lacking in other outdoor magazines.

Although Hunt illustrated for anyone who'd pay the price, he preferred working for *Field & Stream*, where the berets and Panama hats he affected were not considered affectation. Furthermore, he could hunt and fish with the likes of Van Campen Heilner, whose love of liquor and Latin ladies eventually cost him a fortune, and Selwyn Kip Farrington Jr., who charmed his way around countless hotel, restaurant, and equipment bills from Cat Cay to Cabo Blanco to Copenhagen.

I first subscribed to *Field & Stream* while at Lawrenceville—the same prep school that Farrington briefly attended and where *Field & Stream*'s shooting editor, Warren Page, had once taught. I quickly decided that, after college, I'd try to find a way to have *Field & Stream* send me on hunting and fishing trips around the world. Yet it was more than a dozen years after college before I began writing regularly for *Field & Stream*—first, as Kip Farrington's replacement on the saltwater desk; then and now, nearly 30 years later, as conservation editor. I didn't know it at the time, but those dozen years of odd jobs, graduate schooling, and travel—including five years in the navy—and not my academic degrees—are what gave me the credentials and confidence to join Al McClane, Ted Trueblood, Ed Zern, and the other worldly members of *Field & Stream*'s staff.

Still, I felt there was one thing I lacked before becoming a bona fide colleague in that celebrated company. I had to have a Lynn Bogue Hunt painting, preferably one he'd done for *Field & Stream*. My search began at the Easton (Maryland) Waterfowl Festival where I used to sell books near the booth of art dealer Ernie Hickok. When crowds began to thin on Sunday afternoons, I'd stroll over to Ernie's tables to see what works by Lynn Bogue Hunt he had left and at what price.

One day, I found a painting of a jumping green-winged teal drake in the foreground, five black ducks in the middle ground, and a hiding hunter in the background. The work seemed not quite finished, as though Hunt had submitted it for an art director's approval. While still trying to make up my mind, an elderly gentleman walked by, saw what I was holding and said, "I remember that painting; it was a *Field & Stream* cover in the early thirties."

After making sure that Ernie and the unknown gentleman weren't in cahoots, I bought the painting, tracked down a copy of the October 1931 issue on which the art appeared, and framed the painting with the magazine. The two now hang together in my den where some visitors are as intrigued as I am by the seemingly insignificant differences between Hunt's conception and the finished cover.

These illustrations remind us not only of a bygone era in outdoor recreation, but of a vanishing era in publishing as well. Photographs, not commissioned art, provide most covers for modern magazines. Photos are cheaper, and they're what most subscribers want. In 1973, I helped put together a special issue of *National Wildlife* for which we commissioned five of the nation's best wildlife artists to illustrate a variety of endangered species. After the magazine appeared, we received dozens of angry letters from people who insisted that the only time art should be used for wildlife is to illustrate extinct species. So long as an animal exists, it should be photographed.

So, just as a decline in middle-class leisure has meant less opportunity for good field dogs to be turned into great ones, the advent of digital photography has meant the end of opportunity for promising wildlife artists to develop into great magazine illustrators. Young artists today may make a decent living peddling prints through Quail Unlimited, National Wild Turkey Federation, and Coastal Conservation Association fund-raising functions, but they can't become celebrated in the way that frequent exposure in national publications once provided.

Several excellent sporting artists have emerged in recent decades. Some of their work is even technically superior to Hunt's. However, it's doubtful their art will ever stir cultural memories, if not personal ones, the way a Hunt painting can. This is for the same reason that a new decoy—no matter how exquisitely carved—will always lack the pedigree of an old bird which might have been used by a market gunner or even a famous sportsman like Lynn Bogue Hunt.

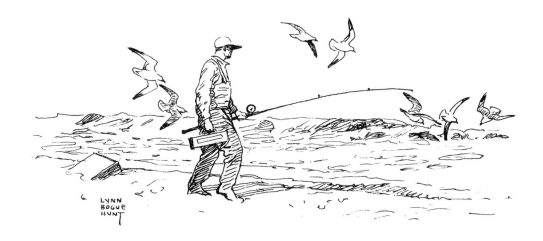

Introduction

Lynn Bogue Hunt lived in two worlds throughout his 82 years. Born into a well-off family, he grew up poor, raised by a single parent: the tattered coat worn to his high school graduation was patched and let out; his mismatched pants secondhand. Money mattered to Hunt the rest of his life.

One of his favorite sayings as an adult was "Art for art's sake, but money for God's sake!" During the Depression his popular and prolific artwork earned him as much as $50,000 a year—about $650,000 in today's dollars. He had money enough then for a maid and a fashionable Long Island address. Concerned with appearances, Hunt dressed meticulously, even when fishing. An immaculate white smock protected his customary painting attire: suit, tie and starched white shirt.

But Hunt spent money faster than he made it. A poor businessman who did not plan for the future, he had spent his wealth by the time he died.

Contradictions marked Hunt's life: Indifferent in the classroom, he assisted scientists as an adult. Though he told family and teachers that he felt most at home in the woods, he resided in or near New York City for more than 57 years. Described as friendly and gregarious, he also struck those who knew him as quiet and self-effacing. An early

conservationist and ardent animal lover, he also advocated catch-and-release gamefishing as early as 1935 and supported Ducks Unlimited's habitat restoration. An urbane man, member of the arty Dutch Treat Club, welcomed at the acerbic Algonquin Roundtable and exclusive Angler's Club, Hunt also was an ordinary suburban commuter much of his adult life, known to his grandchildren as "Papa Toot Toot" because of his daily travel on the Long Island Railroad.

Embarrassed by and ultimately estranged from his independent wife, the artist openly kept a mistress. As a result, Hunt's wife sometimes spent months alone on the east coast of Florida while Hunt simultaneously went to the west coast of Florida, fishing and painting in the company of his girlfriend. Despite their estrangement, Hunt's wife unstintingly cared for him during his last decade, as he grew increasingly dependent when infirmities and lost eyesight stopped his work.

His first published magazine illustration—a line drawing of a strutting grouse accompanying a story he wrote—appeared inside *Sports Afield* in 1897. A 1951 cover painting of mallards coming in for *Field & Stream*—his 106th cover illustration for that magazine alone—book-ended an astounding 54-year career as a leading wildlife artist during the Golden Age of magazine illustration.

Hunt made some of the most recognizable sporting art ever created, including one of the earliest Duck Stamps. He illustrated more than 40 books; executed hundreds of commissioned paintings for corporations and private clients ranging from small canvases to huge hotel murals; and completed about 250 separate cover paintings for nearly 40 different magazine titles, including all the top sporting publications and also general interest publications such as *Boy's Life, Collier's, Better Homes & Gardens,* and the *Saturday Evening Post.*

Despite Hunt's prolific working life and high profile friendships with Ernest Hemingway and other influential sportsmen of his time, only a handful of stories were written about the artist during his lifetime—or since he died. He began, but never finished, an autobiography. He has never previously been the subject of a biographical book. And the first major showing of his dramatic artwork came more than four decades after his death.

Hopefully this book will renew interest in Lynn Bogue Hunt, one of the best sporting artists of the twentieth century, and a fascinating and complex man.

Chapter One

Nature and Nurture: The Formative Years

Nature fascinated Lynn Bogue Hunt as a child. He never outgrew his love of the outdoors. As a grown man, he jokingly claimed that a wild duck delivered him while on its northbound migration.

Hunt was born May 11, 1878, in Honeoye Falls, New York, not far from Rochester. His first name derived from the final syllable of his father's first name, Franklin Fiske Hunt. His middle name, which rhymes with rogue, derived from the Scottish maiden name of his mother, Nancy Cordelia Bogue. Through his mother, who traced her lineage to a Mayflower descendent, he was remotely related to President James Garfield, assassinated just three years after Hunt's birth.

Frank Hunt, his father, owned a sawmill on Ontario Street along Honeoye Creek; about a half mile away Frank Hunt's six older brothers ran Hunt Brothers' woolen mill, also on the creek. As a young lad, he caught crawfish and fished for bullheads and rock bass in the shadows of the mills.

Lynn was the first of three children. His sister, Lena, followed in 1879. His brother, George, was born in 1883.

While a child of just four or five, Hunt cut out recognizable animal shapes, including elephants, cows, horses and birds. He sat with a pan between his legs to catch the snips he made in scraps of paper; members of his family still have the silhouettes and shears. He also began drawing early. By age six, he depicted an animal and then printed the word for it below his picture. His mother, a would-be artist, encouraged his early artwork. A painting of a cluster of chicks she did before his birth hung on the wall of his New York studio throughout his long career.

Village records show his father's mill burned to the ground in 1885, about the time young Hunt moved with his family to Oneida, New York, where they lived with Frank Hunt's youngest sister, Sarah Ellis. Her home bordered the Michigan Central Railroad line, adjacent to a casket factory.

His childhood fascination with nature bloomed in Oneida. Water in particular fascinated him. He often visited the Erie barge canal and Crystal Lake. A nearby marsh tempted him on the way to school, making him late for class. He picked up frogs, tadpoles and snakes, stuffing them into the pockets of even his best clothes. Lynn and his sister, Lena, who often accompanied her brother on his adventures because his male friends found his endless nature study tedious, were both fond of the musky odor of marshes and skunk cabbage plants.

His bedroom filled with nature finds: mounted butterflies and moths, snakeskin sheds, birds' nests and their eggs. When he later learned taxidermy, he began creating realistic family groupings of the birds; as an adult he befriended scientists at New York's Museum of Natural History, including Carl Akeley, a naturalist and collector known as the father of modern taxidermy. Hunt illustrated the museum's magazine on occasion, also painting background landscapes for some of the dioramas Akeley created; in return he had access to photographs and specimens from Akeley and the museum.

Along with a family hunting dog, Lynn kept wild animal pets, such as hawks, a raccoon, a crow, white-footed mice, and cottontail rabbits. He even penned red fox kits in the home's cellar until the stench led to their liberation. A hibernating ball of torpid baby snakes that he had discovered came home in the pocket of a coat, hung up in the family's kitchen. The warmth awakened them and they came wriggling out of his coat pocket. His mother ordered them out of the house. Instead of turning them loose, he placed them in the family's outhouse, where his mother unhappily encountered them a second time.

Another time he got exiled to the same outhouse after a smelly encounter with a skunk. After changing in the outhouse, burying the stinking clothes and washing down the family dog, the young naturalist took a measure of revenge, turning the now-dead skunk into a specimen for his bedroom, which resembled a natural history museum. His New York art studio at 41 Union Square would later take on the same character.

He had other outdoor misadventures. While boating with Lena, their cocker spaniel Patsy stepped on the trigger of his shotgun, blasting a hole through the bottom of the boat. They quickly bailed, stuffed the hole with his sister's petticoat and rowed ashore.

Patsy would not retrieve a live bird; she had a penchant for chicken chasing and frequent punishments made her leery of picking up live birds. Once Hunt wing-tipped a mallard drake. Patsy found the bird in a clump of cattails, but it rallied and flew across the pond unscathed after Patsy refused to fetch. Patsy marked and then trailed the bird for a mile to a clump of thistle near a tree. This time Hunt made certain the bird came down dead, allowing his eager spaniel to retrieve the bird. Hunt also stalked woodcock, snipe, King, sora and Virginia rails, gallinules, coots and many varieties of ducks, especially wood ducks, which he loved for their gaudy colors. A train killed Patsy, "remembered with admiration and great love" by Hunt.

Adventure and hunting tales fascinated him. He read about the escapades of Tom Sawyer and Huckleberry Finn, the treachery and daring in *Treasure Island*, Robinson Crusoe's lonely stranding and about Stanley's adventures in Africa. He also memorized and illustrated epic poetry.

Circuses fascinated him, but not for the performances. He spent his time studying the animals in their holding pens. Back home, he would duplicate the animals, drawing or cutting them out. His mother helped her children fashion a small circus ring beneath four apple trees in their Oneida backyard. It featured a dirt ring, trapezes and even a viewing stand for the neighborhood children, who were drawn to the lanky boy they called "Skinny Hunt."

At age 10, Hunt and his boyhood pals wanted to collect birds. They were not allowed to use shotguns yet, so they built their own primitive gun using a pipe mounted on a crude wooden stock held in place by wire. Plugged at one end, the other end got filled with shrapnel. A piece of corset steel became a crude firing pin, striking a powder charge.

"We killed hundreds of birds with it till the barrel tore loose from the stock one day and narrowly missed killing the boy who fired it," Hunt recalled in a 1935 *Better Homes & Gardens* interview. "We killed sparrows, robins, bluebirds, blackbirds, jays, catbirds—anything we drew a bead on. I got no real satisfaction from the killing; but I did get a kick out of the opportunity it gave me to examine the birds at close range—to handle them, to feel their plumage, to study their colors. They were so lovely that I could hardly bear to put them in my pocket. I wanted to go on looking.

"One thing I began to do very early was to preserve the wings, tails and heads of as many birds as possible, as a help to accurate drawing. I fastened my various specimens to a sheet, putting the head in the middle surrounded by the wings and the spread out tail. . . . Fortunately for me, my mother was a very unusual and understanding person; and she was something of an artist herself."

A major dislocation happened to Lynn at the age of 12: his mother left his father behind in New York state in 1890 and she and her children moved to the town of Albion, Michigan, where she had family. Her brother, Charles Bishop Bogue, ran a grocery store on South Superior Street. Hunt's maternal grandmother, Sally Bogue, also lived in Albion. Lynn, his mother and two siblings moved to 1109 East Porter Street, where his mother took in boarders to make ends meet.

The precise reasons for the separation of Hunt's parents are lost, even to his family. There are some hints, though.

In an unfinished autobiography begun in the early 1950s, Hunt wrote of feeling deceived when he discovered that his father, who advocated abstaining from alcohol, kept a large supply of beer at a lakeside cottage. Hunt also wrote in cryptic notes for the autobiography: "Mother's patience and sympathy. A fine and much abused woman. Father and big ideas." He also wrote his father's business was "on the rocks."

Whatever the reason for the estrangement, the couple never divorced, though they apparently did not reside together for the rest of their lives.

Franklin Hunt eventually followed his wife to Albion, where he attempted an unsuccessful reconciliation. Frank Hunt has been described as making a living during that period as either a tailor or a traveling salesman; perhaps the two occupations were actually one. Nancy Hunt died in 1905, her husband a year later.

Following his move to Albion, a small village at the forks of the Kalamazoo River surrounded by streams, ponds, woods and marshes, young Hunt got an air gun. Then came a 12-gauge Belgian-made shotgun and he began learning taxidermy in earnest.

At first he used a borrowed Hornaday textbook as his guide to preserving game. Later he relied on a mentor, variously described by others as a retired Methodist minister or the curator of Albion College's small natural history collection. (Albion College, where Hunt eventually studied, is a Methodist-affiliated school that began as a seminary. Raised as a Christian Scientist, he did not practice that faith as an adult.) Hunt referred to his mentor in a chapter of *Duck Shooting Along the Atlantic Tidewater*, published in 1947, as "old Mr. Griffin, the town taxidermist," though he also called his teacher a retired Methodist minister in the *Better Homes & Gardens* interview and in his autobiographical notes.

One of the first mounts done with the help of his mentor was a black duck, the grandest bird he had taken at the time. The young gunner initially thought it a dark hen mallard, but Mr. Griffin set him straight: "It's a blackduck drake and quite a prize hear-abouts. Notice his very red legs. He has just come down here from Canada, where this variety breeds. Better mount him. You will not get too many of his kind" (from *Duck Shooting Along the Atlantic Tidewater*).

The young Hunt stuffed the big bird, but did a poor job. The specimen eventually deteriorated, but not his recollections: "The memory of that first blackduck has stayed with him and he has never seen one in the air since without a twinge of the old thrill when his first one jumped out of the cattails of his favorite pothole. After many years of gunning, blackducks continue to command his utmost admiration and respect" (from *Duck Shooting Along the Atlantic Tidewater*).

Waterfowl became favored targets for Hunt, the hunter. They also were favorite subjects for Hunt, the artist, throughout his long career. As he remembered in the introduction of *An Artist's Game Bag*, published by The Derrydale Press in 1936, "There was never a keener gunner than this lad, and in addition to his enthusiasm for shooting he was endowed with a sense of beauty of the game-birds and with an ability to draw them. Since he could not bear to stuff the handsome creatures in the pockets of his shooting coat, he carried paper to wrap them in, one by one, that they reach home unruffled and unsoiled, to become models for the artist."

Taxidermy taught the young artist how animals worked beneath scales, fur and feathers. "An artist needs to know anatomy. Taxidermy involved considerable dissection

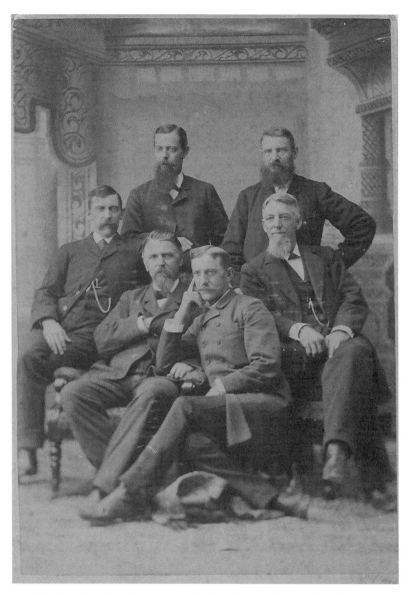

The Hunt brothers of Honeoye Falls, NY. Center, front is Frank Hunt.

Photo courtesy of Marilynn Hunt Guzelian

of birds, animals and fishes, and it engraved every last detail of their makeup on my mind," he said in the *Better Homes & Gardens* interview. Hunt's intimate knowledge of birds in general and waterfowl in particular showed in his artwork throughout the coming decades; many believe wildfowl depiction is Hunt's hallmark work. The state of Michigan recognized his knowledge of birds at a young age; he served as a regional observer of migratory birds during the 1890s, sending in reports from afield.

The appeal of the outdoors was a stronger magnet for young Hunt's attention than school, often leading him to be late—he was never one for hurry throughout his life—or chided for inattention.

His high school history teacher noticed him absentmindedly staring out the window during class one day and she approached to ask why he did not mind her lesson. "I can't, Miss Crosby, I can't. I belong outdoors and that is where I want to be" (from a family history composed by his sister, Lena Hunt Farley, in possession of the Farley family).

He and his mother frequently clashed over school: "I hate, I just hate, to be shut in all day when I want to be outdoors where things are alive and I can see them," his sister Lena recalled him telling their mother as they argued about him finishing high school. "I want to have a hut and live in the woods with just my dog and gun" (from Lena Farley's family history).

The teenaged Hunt knew of two solitary hermits who lived just as he had described: a man known as "Old Dunk" who died in 1868, but became a much-discussed local legend in Albion, and another recluse from nearby Newberg Mills. Referred to as "Old Earhardt," the hermit sometimes walked to town wearing rags, selling vegetables and eggs, and attracting the stares of townsmen.

The romantic appeal of a life alone in the woods eventually was replaced in Hunt's mind with revulsion for Earhardt's rags and filth, according to his sister. Lynn made a jesting drawing of the recluse, displayed in the window of a bank, where Albion townspeople gathered to stare at the lonely figure. The picture caught the eye of H. K. White, president of Gale Manufacturing Company, which produced farm implements such as plows, cultivators and hay rakes. White offered Hunt a job sketching wares for Gale's catalog. Hunt worked summers and many Saturdays for the company in his first paid job as an illustrator.

Impressed with his young employee's natural talent, White gave Hunt $10 and sent him by overnight train to visit the Art Institute of Chicago, where his employer

thought he should study. Hunt was supposedly told there that his native ability and spontaneity would suffer with formal lessons. White also sent his young protégé to the Detroit Institute of Arts, where he briefly studied the depiction of the human figure, something he did not enjoy doing and never executed with the grace and authority evident in his renditions of animals. Even in his mature paintings, people are minor background figures; Hunt seldom painted the feet of hunters or fishermen, obscuring them with brush or boats.

The artwork for Gale funded his twin passions, allowing him to buy paint and paper and also shotgun shells—12 for a quarter—and hunting equipment. The job also satisfied an unfilled need. Hunt settled into his final two years of high school with fewer arguments at home and more interest in his subjects. The would-be dropout even became class president.

Hunt addressed his high school graduating class with a salutary speech on June 10, 1897, at Albion's Methodist Church. During his talk he thanked his mother for encouraging him to pay attention to his education and stay in school. As he stood at the lectern, Hunt wore a worn serge suit coat patched at the elbows with cloth from the suit's worn out pants. The replacement pants, a close match, were bought second-hand.

A picture of Hunt from about that time taken at St. Clair Shores (a suburb north of Detroit) reveals a tall young man with long sinewy arms—he enjoyed split-ting wood. He is standing boldly with one foot on a stump, the other foot on its fallen trunk as a torrent of waters washes beneath him. The young man has a long face, with even features, dark hair and a set jaw. He is holding a rifle across his waist.

Hunt entered Albion College in the fall of 1897. Previous accounts of Hunt's life state he studied at Albion under Professor Franklin C. Courter, director of Albion's art department and a well-known pastoral landscape painter who eventually became best known for a succession of portraits depicting President Abraham Lincoln. In several interviews during his lifetime, Hunt even referred to studying with Courter while at Albion. However, his college transcript does not show him taking a single art class during the two years he attended.

According to an account by his sister, Hunt actually studied with Courter when he turned 16 years old, taking lessons at the college paid for by his aunt, Nancy Bogue White. She also said Courter took a special interest in his young pupil, teach-ing him drawing techniques, mixing color and painting backgrounds. Biographical

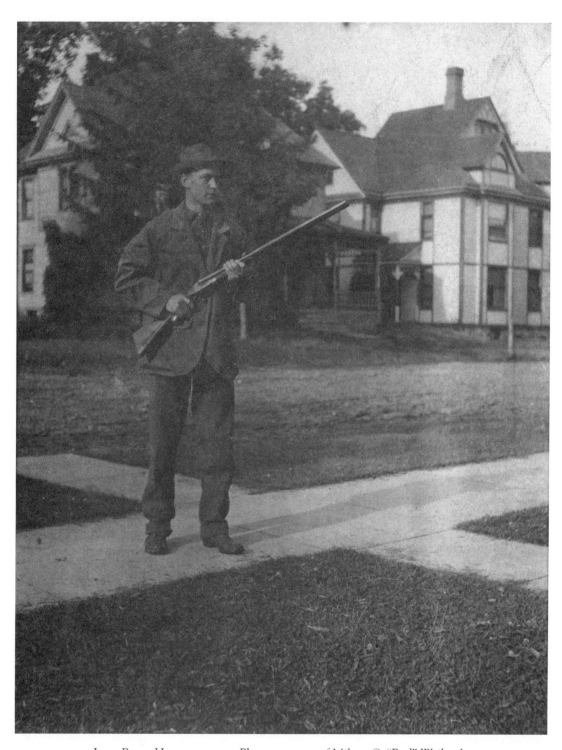

Lynn Bogue Hunt, ca. 1910. Photo courtesy of Milton C. "Bud" Weiler, Jr.

material about Courter indicates he taught at Albion from 1888 to 1895, meaning he would have left the college two years before Hunt became a freshman. It seems likely that Lena Hunt's chronology is correct; Hunt's obituary in the Albion newspaper likewise said he had studied with Courter while still in high school.

Courter was a renowned portrait painter, but evidently of more influence on Hunt were Courter's landscapes. They were predominately quiet pastoral scenes of farmers, barnyard animals, ponds with boats pulled ashore, an empty seaside beach, a campfire. Only a few of Courter's paintings depicted true wilderness. One Courter painting, "Dead Hang," executed in 1888, shows a grouse hanging from a game strap pinned to a rough wall. Hunt painted a similar scene in 1895—the year his sister says he studied with Courter—substituting snipe for the grouse. The painting, which Hunt's relatives refer to as "The Kill," has his cursive signature, Lynn B. Hunt, and is dated. (Hunt did not title paintings and he did not generally date them, though some have dates on the back of the canvas. He began signing his name on his earliest commercial work in script as Lynn B. Hunt, though he sometimes wrote HUNT in printed block letters or just capital H. He eventually printed his name, blocking and stacking his signature on three separate lines, the distinctive signature style he also used on his printed letterhead.)

Courter's academic realism—static landscapes and the game-bird still lifes of both the teacher and his student—exemplify three qualities Courter stressed in his art and to his students: conservative, dignified and reserved. Those qualities are evident in Hunt's very earliest work; the bright hues and drama he became synonymous with evolved through his work as an illustrator.

In a 1941 letter, written by Courter decades after he taught Hunt, the professor fondly recalled his student: "L. B. Hunt was a boy with ambition. He had already collected birds and animals (some frogs and snakes) and had a small bedroom full from ceiling to floor. An apt student. He would watch through a telescope by the hour. I helped him by posing some of his specimens. Give him a credit mark" (from an autobiographical letter by Courter preserved in the Albion College archives).

Hunt, in a 1939 interview for their college alumni association—Courter had studied at Albion as well as having taught there—recognized Courter as "a wonderful teacher and gifted painter." Hunt appears to have kept up with his old mentor throughout their lifetime; he knew in 1939 that Courter continued actively painting at his Cedar Grove, New Jersey, studio. Courter died in 1947.

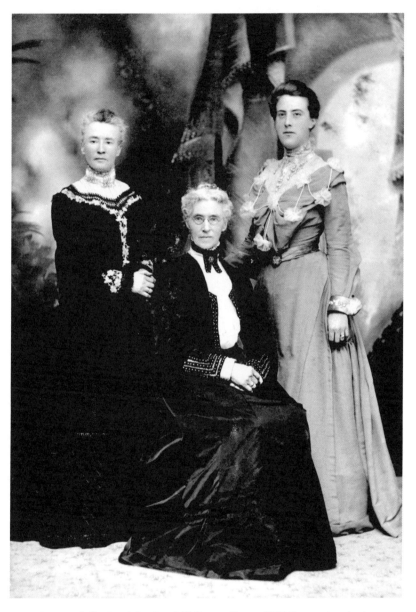

Sitting: Sally Cordelia Garfield Bogue Crane (LBH's grandmother),
left: Nancy Bogue Hunt (LBH's mother), right: Lena Marie Hunt (LBH's sister).
Photo courtesy Jane Marie Gaines

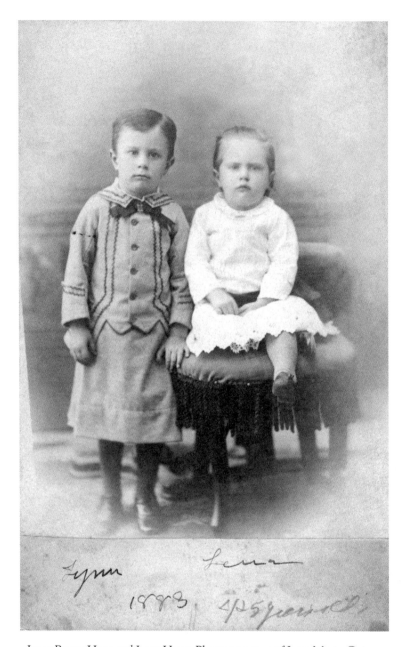

Lynn Bogue Hunt and Lena Hunt. Photo courtesy of Jane Marie Gaines

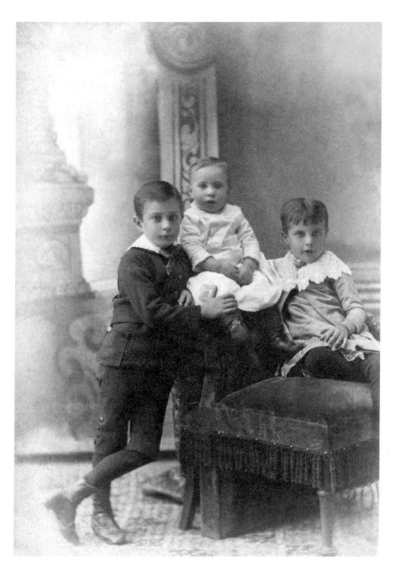

Lynn, George, and Lena—the Hunt children.

Photo courtesy of Jane Marie Gaines

Hunt's classroom indifference shows in his college transcript. Not surprisingly, the only subject that earned Hunt an A in college was biology. He got a B in both astronomy and geology. His grades declined during 1889–1890, his sophomore year, earning nothing higher than a C+; two courses appear incomplete without any grade recorded.

According to his sister, who graduated from Albion, Hunt's biology professor found his student's drawings more accurate than those in the textbook. The teacher had Hunt circulate them among his classmates. Hunt answered just three of 20 questions on a history examination during his sophomore year, according to family lore. He used the remaining test time to draw a picture of Professor Waldo and his little terrier. The teacher kept the picture of his beloved pet and passed Hunt; Hunt's transcript shows he earned a C for the course.

Art increasingly occupied Hunt's attention. An absentminded boy and man in his everyday life, Hunt would sometimes leave his palette on a chair, only to return and sit down on it, ruining the trousers that had to be specially fitted for his skinny frame. He worked at the local hardware store for a short time, but he was not cut out for that work; he repeatedly broke a window glass he was awkwardly attempting to replace. His dexterity as an artist did not translate into ability with most manual chores.

Hunt illustrated the college's 1900 annual, *Pegasus*. Some of the 21 illustrations by Hunt have a flowery, romantic Victorian look, as though influenced by the Art Nouveau movement of the late 1800s. The movement stressed nature and featured sinewy lines and curves. While his early paintings exhibit some of those elements, the influence of Impressionism, a French art movement much in vogue in the late 1800s, is more strongly evident in his better early work. That is especially true in his treatment of the background landscapes of his best paintings.

But most of Hunt's art in the annual is more straightforward and realistic, primarily detailed line drawings. One shows a student composing a letter at a table by lamplight; a stuffed duck is prominent in the background. The closing page of the publication has a photograph of the young artist, hair neatly parted, his long neck covered by a stiff collar with a tie tightly pulled in place. Beneath it reads: "HUNT, HE MADE THE PICTURES."

Hunt made his first sale to a sporting magazine the summer before he entered college. The July 1897 edition of *Sports Afield* features a fussy line drawing of a grouse with the title "A King of Gamebirds" worked into the drawing. Hunt also wrote the

story that went with the art, something he did several times over the course of his career, mostly telling and illustrating waterfowl tales. *Sports Afield* repeatedly used the grouse illustration in its house advertisements over the next several years; magazines back then bought illustrations outright and all their publishing rights, meaning the artist never collected any additional payments when the artwork got reused. Other magazine illustrations, also tight line drawings, ran inside *Sports Afield* while Hunt attended college.

His first cover illustration appeared on the front of *Sports Afield* in the August 1900 issue. It depicted brook trout fishing on the fabled Nipigon River in Ontario. His hometown newspaper, the *Albion Recorder*, reported his success: "The cover, designed by Mr. Hunt, depicts trout fishing in the Nipigon, and in the making of the design the artist has drawn upon the unique experience which he enjoyed several summers ago, which in company with the scientific expedition of Albion College, he made a trip through that almost unknown region" (from a copy of the *Albion Recorder* story contained in the Albion College archives). The newspaper also reported that the magazine's editor spoke flatteringly of Hunt's work.

An Indian hunter carrying a turkey adorned the December 1900 issue of *Sports Afield*. Hunt's depiction of a heron in a wooded setting appeared on the cover of the January 1901 issue; *Sports Afield* repeated the cover in various forms at least 12 times. Additional early cover illustrations through 1903 by Hunt depicted geese in flight, a moose, a fox chasing grouse, a heron fishing and an antelope. He also did a small amount of work for *Outing*, *Forest and Stream* and *Shooting & Fishing* magazines during the period. *Outing* used his art and his stories: one painting showed a pair of shovelers in flight that was clearly influenced by John James Audubon, but another painting of wood ducks stalked by a hunter and his spaniel already demonstrates his distinctive flair for the moment of drama between prey and hunter.

His first *Field & Stream* cover, featuring Indians performing a snake dance, did not run until 1904. A white-tailed deer cover appeared at the end of 1908. Hunt would not appear on the cover of *Field & Stream* again until 1924, beginning an incredible run of covers that lasted until 1951.

Though more closely identified with *Field & Stream* magazine, *Sports Afield* clearly launched Hunt's career. Hunt's artwork appeared repeatedly on the cover of *Sports Afield* through 1919. Many of the covers were repeats and some were unsigned, though clearly Hunt's distinctive work.

During the period just after the turn of the century, Hunt courted his future wife, Jessie Bryan, of Wyandotte, Michigan. The daughter of a Civil War sharpshooter who became a lighthouse-keeper, Jessie Bryan grew up on the water, sailing solo to and from their island home to high school. She likely met Hunt sometime between 1898 and 1899 while taking a one-year commercial course at Albion College. A photograph from 1902, when she worked as a secretary in Lansing, shows a pretty blonde woman with just the hint of a mischievous smile.

Out of college, Hunt took a job as a draftsman for the Fulton Engine and Ironworks in Detroit in the summer of 1899. By September, he had joined the *Detroit Free Press* as a staff artist, eventually working for the Sunday edition, mostly illustrating fiction and special feature stories. He continued drawing freelance sporting art illustrations for *Sports Afield* in his off hours. He worked for the *Free Press* for three years, but unfortunately a 1925 fire there destroyed his newspaper artwork. However, members of his family still own one of his whimsical newspaper illustrations, a father bear carrying a blunderbuss in one hand and a turkey in the other as five happy cubs dance. His sister, Lena, wrote a children's story to go with it which the *Press* printed.

He nearly got fired from the *Free Press* when an actor he had drawn appeared in the Sunday paper with a thick mustache—the clean-shaven actor played Hamlet. The enraged drama critic wanted Hunt fired. But the scribe instead wrote a letter of apology after Hunt proved that a press smear, not his artwork, had made the figure hirsute.

Hunt's weekends were spent on Grassy Island, Jessie Bryan's home on the Detroit River. He spent his free time there watching nature, particularly ducks. The island, known for its production of wild celery, a favorite staple of waterfowl, is now a National Wildlife Refuge. Invited to a family party on the island, he did not appear at the gathering. Instead of socializing, Hunt had climbed a nearby willow tree overhanging the water. Silently stretched out on a branch, he intently watched a hen and her brood of ducklings.

Ambitious and encouraged by sales of his commercial illustrations, Hunt moved to New York in 1902, taking up temporary residence at 10 West 64th Street on the Upper West Side. He enrolled in the Art Students League of New York at their new headquarters at 215 West 57th Street on November 24. His first class, in antique art, required drawing from casts with biweekly criticism from instructor Kenyon Cox, an academic classicist trained in Paris. A formal evaluation process demonstrated proficiency; there were no tests or memorization, something that must have pleased

Untitled. This is typical of Hunt's illustrations that were used for calendars, ca. 1920. Watercolor on paper.
From the collection of Paul Vartanian.

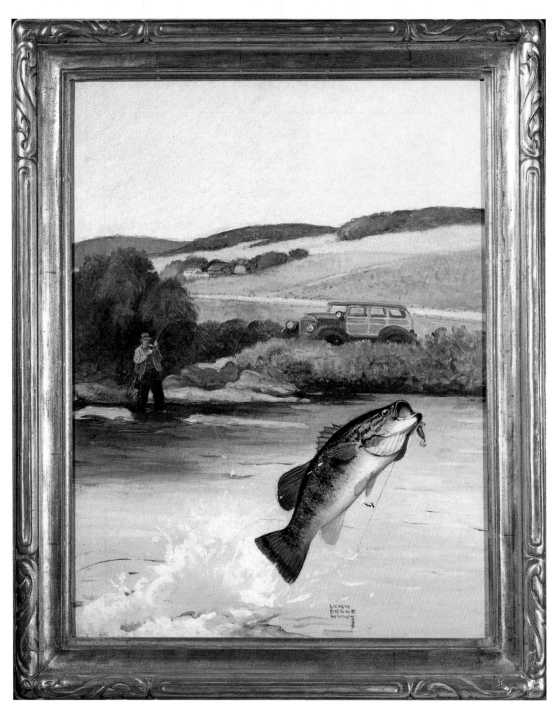

Untitled. Bass fishing scene used for cover of Field & Stream, *June 1944. Oil on canvas.*

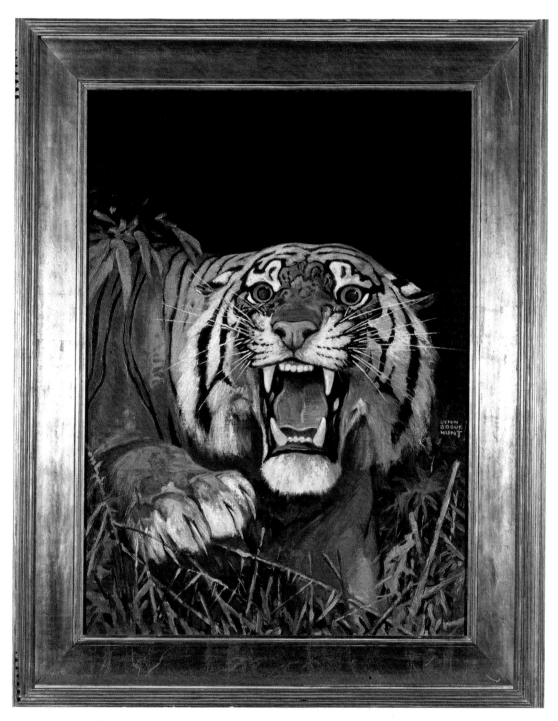

Tiger. Cover of Field & Stream, *August 1936. Oil on canvas.* From the collection of Paul Vartanian.

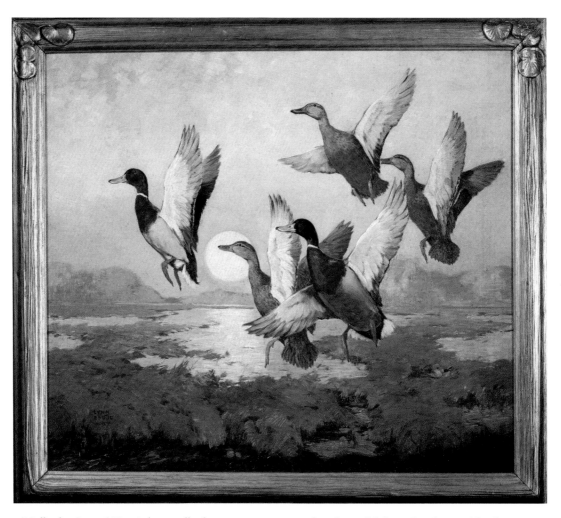

Mallards. One of Hunt's best mallard paintings, ca. 1925. In a beautiful frame hand-carved by the artist.
From the collection of Paul Vartanian.

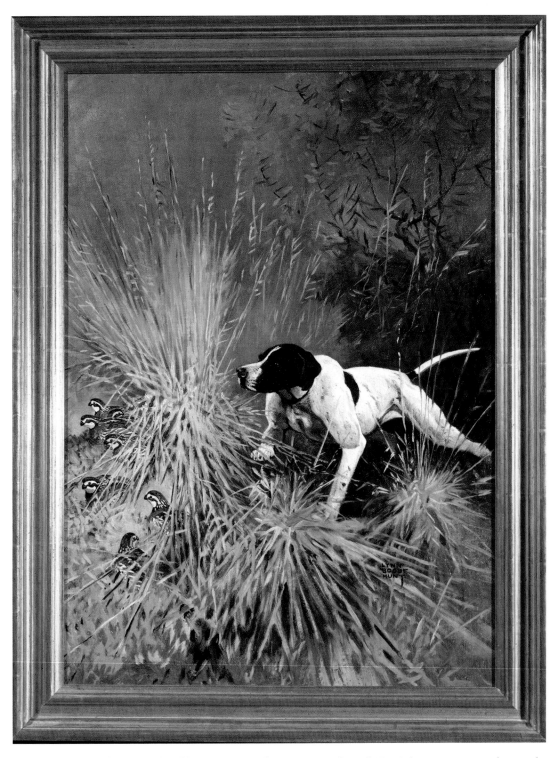

Pointer. Used for the cover of Field & Stream, *February 1940. One of Hunt's best paintings, and certainly his best dog painting. Oil on canvas.* From the collection of Paul Vartanian.

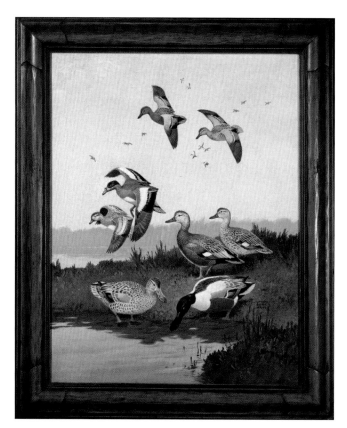

Waterfowl and turkeys. Two of the paintings used for the Game Birds of America set of prints published by Field & Stream *in 1946. Oil on canvas. From the collection of Paul Vartanian.*

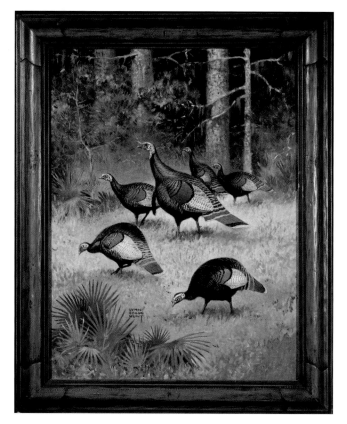

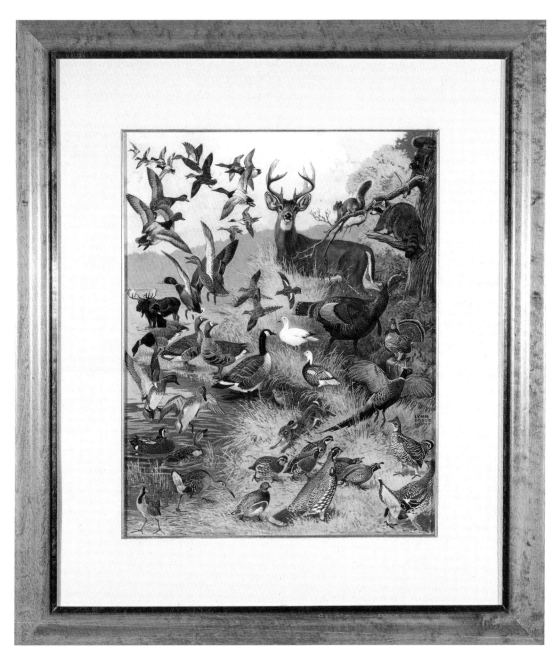

Game Scene, ca. 1925. This was originally commissioned by Remington for a calendar, but later it was
slightly altered by the artist and used by Field & Stream *as a cover for a recipe book. Watercolor on Paper.*
From the collection of Paul Vartanian.

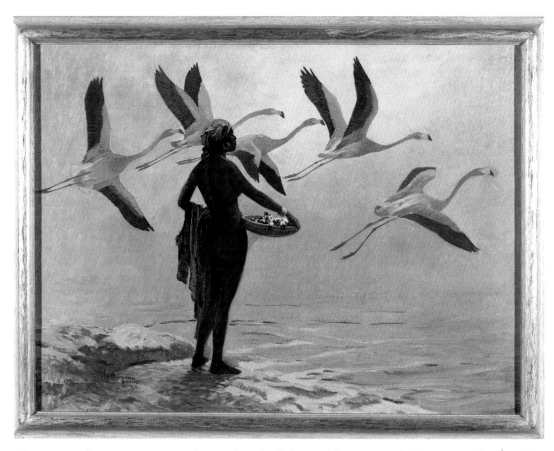

Flamingos with woman, ca. 1925. A scene from the Bahamas. The woman is holding a tray of stone crabs.
This is similar to a painting that Hunt did for a cover of Boy's Life *in 1925. Oil on canvas.*
From the collection of Paul Vartanian.

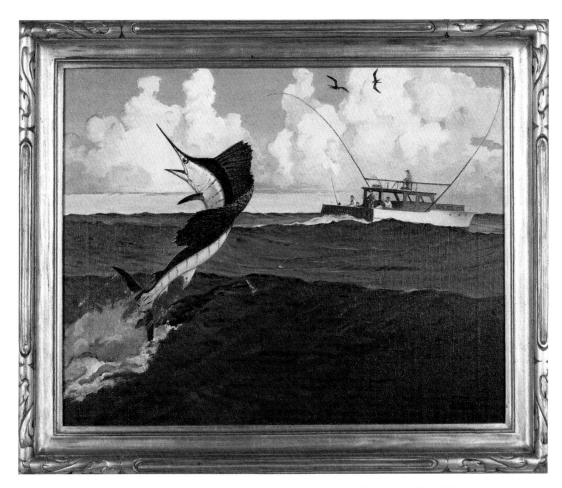

Sailfishing off Miami, ca. 1930. Oil on canvas. From the collection of Paul Vartanian.

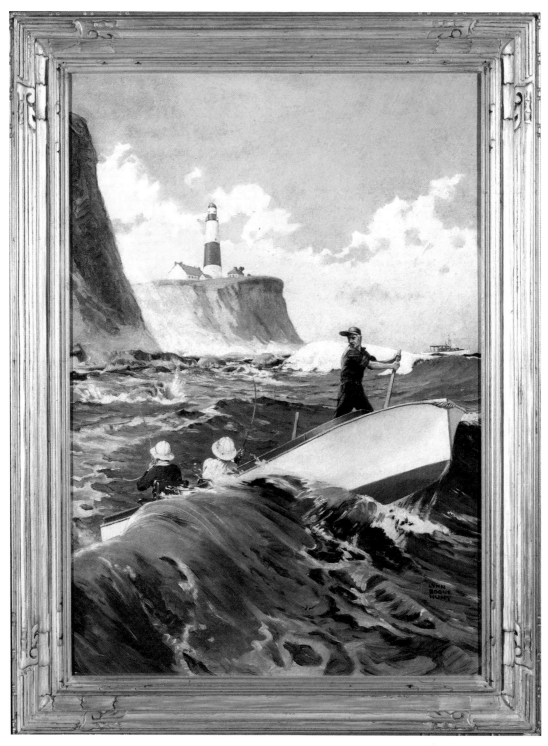

Fishing off Lighthouse at Mantauck, New York, for Striped Bass. Used for the cover of Field & Stream, *March 1936. The scene shows Lynn Bogue Hunt and Otto Scheer in the boat, Pumpkinseed. Scheer mentions this scene in a chapter he wrote in* American Big Game Fishing *published by The Derrydale Press in 1935. Oil on canvas.* From the collection of Paul Vartanian.

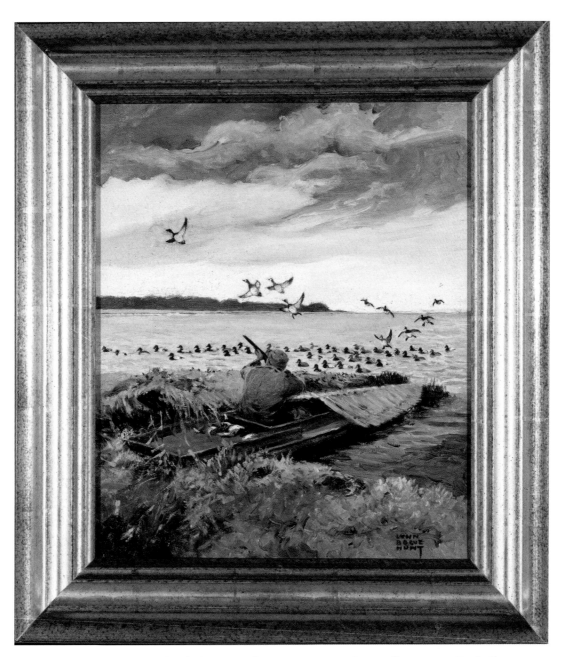

Broadbill Shooting from a Thatched Pontie. This painting was used as an illustration in Duck Shooting Along the Atlantic Tidewater, *published by William Morrow in 1947. This image depicts hunting along the Great South Bay of Long Island. Oil on canvas. From the collection of Paul Vartanian.*

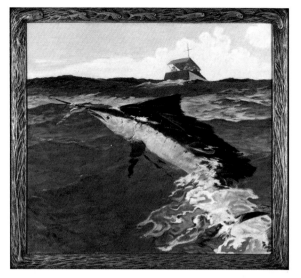

The Take, 1931. First set of three. Frontispiece for American Big Game Fishing *published by The Derrydale Press in 1935.*

The Fight. Second set of three. Cover of Literary Digest, March 1931.

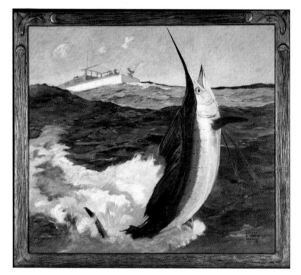

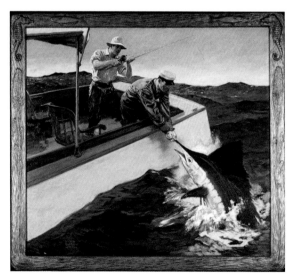

The Capture. Third set of three.

These three paintings are all framed alike in frames hand-carved by Hunt. All are oil on canvas.
From the collection of Paul Vartanian.

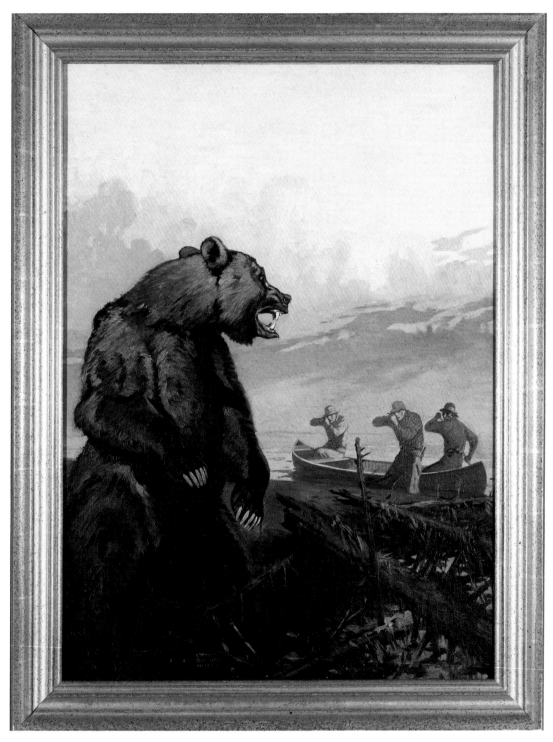

Grizzly Bear. Used for the cover of Field & Stream, *December 1935. Oil on canvas board.*
From the collection of Paul Vartanian.

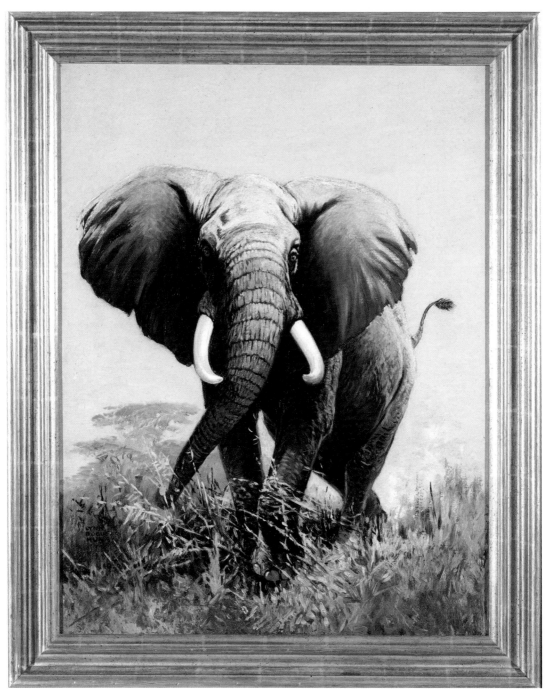

Elephant. Used as a cover of Field & Stream, *December 1935. Oil on canvas board.*
From the collection of Paul Vartanian.

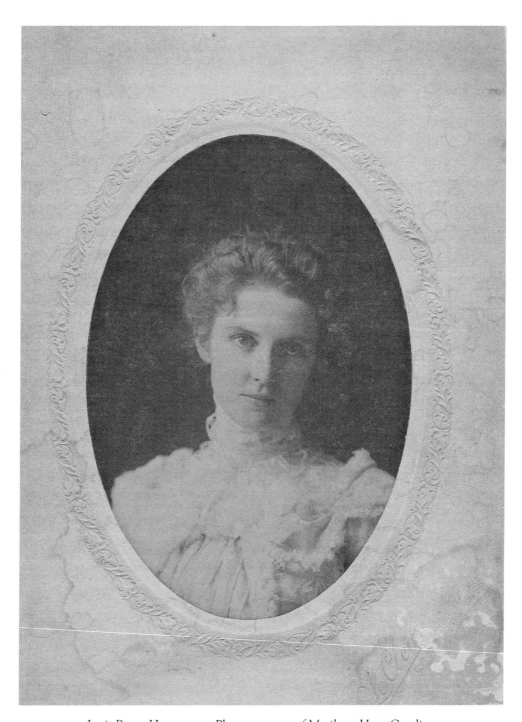

Jessie Bryan Hunt, 1902. Photo courtesy of Marilynn Hunt Guzelian

Hunt. He evidently passed the evaluation: on December 29 Hunt enrolled in the advanced antique art class, taught by Charles C. Curran. That class finished on January 30, 1903.

The classes at the Art Students League ended Hunt's formal art education. It also marked the beginning of his new career: full-time freelance illustration and art in the heady atmosphere of bustling turn-of-the-century New York.

Chapter Two

Making Connections: Advertising Age

Hunt won a commission for a 1902 duPont Powder Co. calendar depicting a woodcock. It was the first of many advertising assignments—Hunt illustrated for life insurance, dog food, pet care products, camping equipment, ammunition manufacturers, and arms and fishing companies. Even Murad cigarettes featured a Lynn Bogue Hunt alligator clutching a pack of smokes in a toothy grin.

Advertising work sustained Hunt in his early years and he continued to do some ad work through the early 1940s. Indeed, his greatest early acclaim as a sporting artist would come as a result of a wildly popular portfolio of American gamebirds he did for duPont, a major ammunition manufacturer.

In addition to duPont, the companies he eventually created advertising art for included Ithaca Gun Company; Hercules Powder Company; L.L. Bean; Liberty Mutual Insurance; Sargeant Pet Products; Pflueger; Remington Arms Company; Savage-Stevens Arms; Union Metallic Cartridge; Western Cartridge Company; Peter's Cartridge Company; and Winchester Arms Company.

The advertising work led to private commissions; companies then were run by strong-willed men, not executive committees beholden to stockholders. Many of the

men who ran outdoor companies were committed outdoorsmen who admired Hunt's commercial work and wanted to see more of his work in their homes and offices. Through early advertising art connections, Hunt met and befriended the leading sportsmen of his day. Often he ended up working with—or for—them, frequently spending time in their homes, clubs, country retreats and yachts. He emerged as a celebrity in the world of sporting art by the 1930s, staying gratis as an invited guest at resorts trying to attract new customers.

Through his advertising work, Hunt became friendly with men such as Winchester's John Olin and the duPont company hierarchy. He depicted Olin's Labrador retriever, King Buck, and did commissions for the duPonts, some of which are still maintained at Eleutherian Mills, the site where America's first gunpowder was produced. Upper levels of the sporting world then were smaller and less democratic than now, forming an interlocking society of affluent consumer sportsmen, wealthy manufacturers and influential writers and journalists who all knew each other.

"They fed off of each other," remembers Dick Howell, whose father, Tom Howell, managed Panther Ledge, one of the New Jersey estates where Hunt and his circle were frequent guests. "They were well-read, well-educated and so much more traditional. It was not just a day's shooting" (interview with Dick Howell, March 2002).

Hunt not only painted and befriended them, he also curried their favor. He made hand-carved frames with an outdoor motif for their paintings, designed signature pins for their businesses or estates, even constructed a panther-shaped weather vane for Clen Ryan, one of his best patrons and the owner of Panther Ledge. Hunt even spent a month at Roger Selby's Arabian horse farm in Ohio, doing art for a privately printed book memorializing Selby's finest studs and mares.

"He was priming the pump to please these folks," explains sculptor Dale Weiler, who grew up visiting Hunt with his father, artist Milton C. Weiler. "Most artists then were dirt poor, but he made money. He was very busy. These were artistic thank-you notes. It was a wonderful system and it worked" (interview with Dale Weiler, February 2002).

Besides Olin and the duPonts, Hunt's prominent patrons and friends over the years included writer and fisherman Zane Grey; tackle maker Al Pfleuger; writer and sportsman Ernest Hemingway; guide Tommy Gifford; guide Bill Hatch; sportswriter Grantland Rice; sportsman, writer and Derrydale Press owner and publisher Eugene V.

Connett 3rd; sportsman Hiram Blauvelt; retailer, fisherman, naturalist and philanthropist Michael Lerner; sportsman, footwear maker and horse breeder Roger Selby; sportsman Clen Ryan; fisherman and jeweler Otto Scheer; *Field & Stream* saltwater editor Selwyn Kip Farrington Jr.; *Field & Stream* editor Ray P. Holland; *Field & Stream* associate editor Van Campen Heilner; and *Field & Stream* owner and publisher Eltinge F. Warner.

It was a heady crowd for a personable Midwest country boy filled with ambition—and talent.

"The Kill." Lynn Bogue Hunt's earliest known work—dated 1895. The influence of Frank Courter is clearly shown. Photo courtesy of Steve Scharboneau

Chapter Three

Journeyman Years

Flush with success, Hunt returned to Michigan—briefly. With his career successfully launched, the 25-year-old artist decided to marry.

Hunt wed Jessie Bryan on Grassy Island on the 11th of June 1903, with his brother, George, as witness and presumably also his best man. Fifteen adults, including his mother—but not his father—signed the couple's wedding book, which remains in the family.

The Hunts spent their honeymoon getting to New York. The steamship *Western States* left Grassy Island and headed through the Great Lakes, passing by Detroit, Buffalo and Niagara Falls. The couple went inland at Rochester, visiting Hunt's original childhood home in Honeoye Falls for three days where his uncles' woolen mill still operated. (It burned to the ground in 1911.) In Albany, the couple caught another steamer and headed down the Hudson River to New York, "a delightful trip," Jessie Hunt wrote in their wedding book. They caught a ferry to Staten Island and on July 2, 1903, set up housekeeping at 11 Horton Row.

He made $3,500 that first year in New York, the current equivalent of $70,000. Lynn Bogue Hunt had arrived.

Then only 25 years old, Hunt remained in metropolitan New York until he died. But the increasingly cosmopolitan artist always found time to reconnect with the outdoors.

As he recalled in chapter 6 of *Duck Shooting Along the Atlantic Tidewater*,

When this young man took the bit in his teeth, deserted a living job on a Detroit newspaper for that Mecca of all ambitious artists, New York, he settled himself there, began peddling his wares and looking over the shooting possibilities. He picked Staten Island as a place to live, where rents were cheap and he could enjoy the never ending glory of the ferry ride to the city. In spare time he hunted the marshy shores of the island and discovered, to his amazement, black-ducks galore. No mallards, no pintails, no teal—just Blackducks, except for scoters and old squaws off shore. And all this in a borough of the great city only a few miles away.

When he was better established as an artist and had more time, he discovered the black-duck possibilities of Long Island, with its endless bays and marshes, its wooded streams, and, best of all, its little ponds lying in the pine woods to the east.

Hunt's early days in New York were spent simultaneously building a family and a career. His first son, Lynn Bogue Hunt Jr., was born in 1907 while the family lived at 189 Claremont Street, in the Morningside Heights section of Manhattan, near Columbia University. The junior Hunt, called Bogue to distinguish him from his father, eventually studied at the College of William and Mary. Bogue tried to join the United States and Canadian Air Corps during WWII, but got turned down. He worked as a supervisor in the Grumman aircraft plant on Long Island during WWII, and later he worked for Eastern Airlines in Miami. Eventually he moved back to Long Island, where he owned a wholesale hardware business. With his wife, Gladys Keefer Van Tassel, the junior Hunt had a son, Lynn Bogue Hunt III, often called Boguie to distinguish him from his father, and a daughter, Marilynn, also named in honor of her grandfather. Bogue and his family moved into his father's Williston Park, Long Island, home during the Depression and lived there until 1950, when they built a home nearby on Fox Hunt Lane in Cold Spring Harbor. Lynn Bogue Hunt Jr. died in 1974.

The Hunts expected a girl when their second child was born in 1908; unprepared with an appropriate name, the little boy became Bryan Hunt, using Jessie Bryan Hunt's maiden name as his first name.

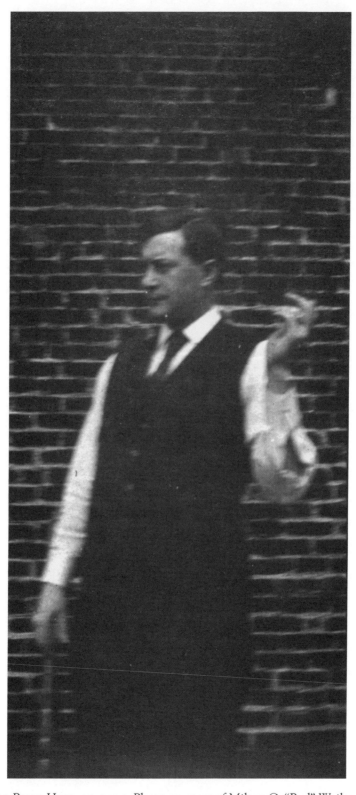

Lynn Bogue Hunt, ca. 1915. Photo courtesy of Milton C. "Bud" Weiler, Jr.

Bryan Hunt graduated from the University of Michigan when just 19. He went to work in Southeast Asia for the company that eventually became Mobil, the giant oil conglomerate. He received military training and earned a master's degree at Columbia at the outset of WWII and served on Admiral Chester Nimitz's staff in the Pacific. After the war, he returned to the oil company, working overseas as a top executive. Eventually he settled in California, marrying Doreen Struthers. They had a son, Alan Bryan Hunt, and a daughter, Diane Hunt. Bryan Hunt also died in 1974.

Though both of Hunt's boys were exposed to fishing and hunting as children—Bogue won the betting pool at a gamefarm once by shooting a white pheasant—neither hunted as adults. Bryan Hunt fished throughout his life; his brother, Bogue, did not fish as an adult. Hunt tried unsuccessfully to interest his oldest grandson in the outdoors, but the boy got seasick while fishing and blew a hole through the floor of a duckboat with a shotgun, putting an end to his outdoor career. Hunt's other grandchildren did not become outdoors people either.

Hunt made a good living during his early years in New York doing advertising art. But not until he turned 39 years old in 1917 did he hit his stride. Advertising work made his name.

Hunt's career took off that year after duPont published "Our American Game Birds," a collection of 18 color prints accompanied by a 56-page text by E. H. Forbush. The prints soon were found everywhere tacked up or framed in sportsmen's homes, garages and cabins. One version sold then for $2; another $5, the equivalent of about $25 and $70 today. DuPont continued using Hunt's art on calendars and prints into the 1970s, more than a decade after he had died and more than two decades after he stopped painting. To this day his advertising art remains highly collectible.

Many of the original duPont portfolio pictures reappeared in 1918 as magazine covers on *American Shooter*. They appeared again 23 years later when they were made into a book also titled *Our American Game Birds*. This time his friend Van Campen Heilner wrote the text. Hunt repeated the success of the original portfolio concept several times during his career, painting several different collections. *Field & Stream* distributed his best-known subsequent portfolios during the 1940s.

The year 1917 also marked the first time Hunt crossed over to illustrate a general interest magazine. *Leslie's* printed a Hunt cover of two eagles fighting in May, and *Delineator* published a Hunt butterfly on its August cover. As WWI raged on in Europe

and the United States finally officially entered the fray, *Leslie's* printed a soldier by Hunt on its November cover. The soldier may be Hunt's only cover illustration showing just a person, not an animal or nature scene that also features a person.

Hunt soon routinely did work for general interest magazines, such as *The Country Gentleman* and *American Boy*, as well as outdoor publications during the early 1920s. He also did a small amount of work for *Outdoor Life* during the period, a cover and a back page.

The artist joined the selective Society of Illustrators in August 1923 and also helped found the Society of American Sporting Art sometime later. By at least the early 1920s he had already permanently established his studio at 41 Union Square, a workspace he maintained until he died.

The studio was generally off-limits to family; similarly, Hunt seldom discussed his work or hunting and fishing at home. Making art for the most part was a 9 a.m. to 5 p.m. occupation conducted at the studio, but it was also completely intertwined with his sporting life; outdoor pursuits and painting fed each other. Hunting and fishing, which he seemed to love equally and did continuously, shared Hunt's time with his artwork. At the same time, Hunt enjoyed comfort; he did not routinely go camping or hiking, even in pursuit of sports he loved.

In 1921 Hunt illustrated his first book, *Prince Jan, St. Bernard*, written by Forrestine C. Hooker, a dog book. Many believe Hunt's canine art is a close second to his depiction of birds; he knew dog conformation well enough to judge hunting class competitions at American Kennel Club events. Hunt's book illustrations and line drawings, primarily done in the following two decades, would eventually become some of his most familiar and cherished work.

Chapter Four

Field & Stream: The Middle Years

The pictures Hunt is most widely identified with, a continuous stream of arresting cover illustrations for *Field & Stream*, began in 1924, appearing every year—sometimes as many as seven times in a 12 month span—until 1947. There was no Hunt cover in 1948; he produced a single cover in 1949. His final *F&S* cover ran in 1951, bringing an end to an extraordinary connection between a man and a magazine.

According to Hugh Grey, editor of *Field & Stream* for about 30 years beginning in the late 1930s, Hunt's longevity came, in part, because he was easy to work with. "He was a kind and gentle guy, appreciative of the work of younger writers and artists. I was very fond of Lynn. He was friendly, but he was also quiet. He didn't throw his weight around—and he could have. He wasn't temperamental like a lot of artists" (from an interview with Grey, April 2002).

Grey says Hunt's covers decorated the walls of the magazine during his tenure; back then, publications bought the art outright. Hunt usually got between $300 and $400 for a cover commission, the equivalent of between $4,000 and $5,000 today. Hunt's waterfowl paintings are his best cover work, Grey believes.

Hunt's long association with *Field & Stream* brought many benefits, chiefly a reliable paycheck—a huge concern for a freelance artist—and a measure of prestige and recognition. But it also brought some things less tangible, but ultimately more valuable: connections, collaborations and friendships.

Hunt's career peaked in the 1930s, after he turned 50. It is no surprise that beginning in the 1930s and lasting through the 1940s, Hunt illustrated many books written by *F&S* regulars, such as Heilner, Holland and Farrington—especially Farrington.

Together, Farrington and Hunt wrote and illustrated eight books: a charming book about a swordfish written for children; a book about gamebirds; a book praising Ducks Unlimited's habitat work; and five angling books, four of which are now-classic saltwater titles: *Atlantic Game Fishing*; *Fishing the Atlantic, Offshore and On*; *Fishing the Pacific, Offshore and On*; and *Pacific Gamefishing*.

The two were an odd pair: Hunt, a quiet and gentlemanly artist who fished in a white shirt and scarf, with a black beret or wide Panama hat topping off his now-white head of hair; Farrington, a flinty, opinionated and often self-aggrandizing writer who preferred beat up Bermuda shorts and a polo shirt, topped off with a tattered broadbill cap. Farrington came from money, attended private prep school, held a seat on the New York Stock Exchange, but was also a cheapskate who used a neighbor's telephone to make long-distance calls without ever offering to pay the bill; Hunt grew up poor, made money and a name on his own and spent cash as fast as he made it. Hunt was born in 1878; Farrington 1904. But they had two things in common: they both loved duck hunting and bluewater fishing.

Hidden away on Highway Behind the Pond, Farrington's East Hampton ranch house, which was decorated with work by Hunt, Aiden L. Ripley, Richard Bishop and Roland Clark, became a frequent destination for Hunt. The garage held many of Farrington's—and his wife's—angling honors, as well as a picture of Sara Chisolm Farrington in her wedding dress. Farrington claimed he wanted all of his greatest accomplishments in one location. His wife, known as Chisie—a nickname supposedly bestowed by Ernest Hemingway—was a world-class angler in her own right. She had a different reaction to the photo's placement with her husband's outdoor conquests. "If I'd been holding a duck, I might have made it to the bedroom" (from a March 2002 interview with Bruce Collins), she told friends who asked about the picture. Indeed, Kip Farrington arranged their honeymoon so the couple could spend most of their time fishing. The Farringtons squabbled often, yet were devoted in their own way.

Lynn Bogue Hunt, ca. 1930. Hunt used a shadowbox to make a drawing from the photograph.
Photo courtesy of Milton C. "Bud" Weiler, Jr.

Kip Farrington, who loved trains and hockey nearly as much as he loved duck hunting and fishing, traveled in the pursuit of sport so much it appeared to friends and neighbors he had no time to write, despite decades spent with *Field & Stream* and about 20 published books. Whenever he left on a major trip—he pioneered fishing off Chile and other then-exotic locations—Farrington left his manuscripts at a neighbor's in a battered leather suitcase.

Recruited by Farrington, Hunt served as a judge in the annual International Tuna Angling Match held off Nova Scotia during the mid-1930s. The artist also designed the winner's trophy, known as the Sharp Cup.

Farrington more than likely also facilitated the friendship Hunt developed with Michael Lerner, who spent much of the fortune he made running a chain of women's clothing shops on fishing and studying fish, even going so far as to underwrite a private research facility in Bimini. Lerner founded the International Game Fishing Association in 1939. The group, which is still prominent today, sets standards and keeps angling records. Hunt designed the IGFA's first logo, showing a swordfish and

several tuna. Hunt posthumously became a member of the organization's hall of fame in 1999, in recognition of his angling art.

Hunt painted fish and freshwater fishing scenes from the start of his career. But offshore gamefishing and the art that captured it was a relatively new thing in the 1930s as advances in boats and fishing tackle made the sport possible—for those who could afford it. Hunt's wealthy friends and patrons invited him along because they wanted him to capture them—and their great fish—on canvas.

Due to the ephemeral coloring of fish, fading by the second after they are boated, Hunt modified the way he worked. Although Hunt was essentially a studio artist, while outdoors he would make sketches, take photographs or sometimes paint a small ROUGH—he generally labeled them that way right on the initial painting, usually done in opaque watercolor known as gouache. But he did his finished work in the studio, working almost exclusively with oil paint. Later in life, as his health and eyesight failed and he traveled less often to Manhattan, Hunt set up a basic workspace in the spare bedroom of his home in Williston Park on Long Island. An easel and a desk for painting filled the cluttered room. Feathers, decoys and other reference materials were pinned or taped to the walls.

He worked differently with gamefish paintings, frequently making detailed piece-by-piece color studies of fish, often with notes about subtleties of their coloring. Eltinge Warner, the founder of *Field & Stream*, recounted Hunt's tale of his tangle with a boated fish: "Someone hooked a sailfish, and I got my paints on the palette. The captain furnished me with water in a teakettle, which was the only vessel capable of holding anything in that pitching boat. The sailfish was brought alongside, and I insisted that he be brought aboard without getting the headache-stick, as any fish begins to change color as he is struck on the head. That sailfish took two men to hold him down while I got his colors! He was thrashing and flopping and throwing salt water and gurry all over me and everything else in the boat while I worked. In the middle of all this another one was hooked and the crew deserted me, which left me alone to fight it out with my sketch and the fish!" (From Warner's 1946 introduction to Hunt's fishing portfolio.)

According to Warner, Hunt also did something else differently when he painted a gamefish scene: He sketched the outline of a fish and then painted it in true colors after a specimen got hooked. Only later did he fill in the background with a boat, fishermen and the sea.

While some of Hunt's fishing scenes rival the dynamic realism he achieved depicting bird hunting, his changed work method helps explain why many of Hunt's saltwater scenes do not completely cohere: The fish is right; the background is right; but the overall picture is often awkward, as though a static decal of a fish had been applied atop a dynamic seascape. Hunt sometimes had similar problems with big game depiction.

Over the decades, Hunt explored much of America's east coast: billfishing as far south as Ernest Hemingway's island hideaways; dory fishing with Michael Lerner for tuna as far north as Wedgeport, Nova Scotia; judging a fishing tournament with Farrington as far east as Bermuda. His most frequent haunts, though, were New Jersey and Long Island waters. His friend Van Campen Heilner belonged to a private duck club off Harvey Cedars, Long Beach Island, New Jersey, where he entertained Hunt. The artist wrote about going out on New Jersey's Barnegat Bay before dawn, and also duck hunting on Long Island, in *Duck Shooting Along the Atlantic Tidewater*. The tip of Long Island, Montauk Point, was another favorite haunt. Hunt often stayed with the Farringtons in their nearby East Hampton guest house.

Despite occasionally painting charging elephants and big cats, Hunt never once ventured across the Atlantic Ocean. He had plans once to go to Africa with members of the Museum of Natural History, but Carl Akeley's unexpected death in 1926 put an end to that plan. Hunt's big game paintings drew inspiration from a mixture of his imagination, photographs—taken by Akeley, Hunt and others—and sketches made at zoos. Later, Hunt began using a 16-millimeter moving picture camera to capture the movement of animals he had not seen in the wild. Hunt delighted in enlarging tiny creatures, such as crabs and insects, making them large enough to fill a projection screen as he studied them. He also frequently shot at 64 frames per second and then replayed it at 16 frames, turning it into a slow-motion picture to get the movement right. But Hunt admitted that pictures were only an aid when it came to getting it right on canvas. He seldom or never hunted white-tailed deer, according to family; penned deer and pictures were the source for his art. Deer are probably his least successful subjects, blocky and static, like stout ponies with antlers strapped in place, not completely at home in their background landscape.

Chapter Five

The Dean and Derrydale

The 1930s marked the decade when Hunt became the recognized dean of American sporting artists and also the period when he began illustrating books for The Derrydale Press, America's premier sporting publisher.

Eugene V. Connett 3rd, a New Jersey native and Princeton University graduate, founded the press. Fine British sporting books and art, particularly etchings, drypoints and aquatints, which he collected, fascinated him. The family hat manufacturing business bored Connett, so he sold it in 1925 and went trout fishing while he considered his future. He soon took a job as a printing salesman, intent on learning about publishing from the bottom up. In 1926, Connett formed a relationship with the publisher of Merrymount Press, Daniel Berkeley Updike, then America's foremost book designer and typographer. A year later, Derrydale's first imprint, *Magic Hours*, a trout fishing book authored and produced by Connett, came out in an edition of only 89 copies. Most were sold or given away to fellow members of the Angler's Club of New York; Connett, an active member, produced the club's newsletter beginning in 1920.

Connett hosted Hunt at the Angler's Club meeting space on Hanover Street from 1927 through 1940. Hunt remained only a guest though; the dues were quite

high and rules barred doing business at the club, which would not have appealed to Hunt's commercial instincts. The artist reciprocated Connett's hospitality, endorsing his publisher's membership in the Dutch Treat Club, a social club primarily for artists and writers, in November 1937. Connett thanked him for his help joining the club, writing: "I understand it's worse than getting into heaven!" (From correspondence between Hunt and Connett in the Derrydale Archives maintained by Princeton University Library.)

Hunt's first Derrydale illustrations were for Connett's 1930 book, *Upland Game Bird Hunting in America*, which was published in an edition of only 850 copies. But his most important works for Derrydale were yet to come.

In 1935, he illustrated two Derrydale titles, one by design, and one by chance. The first book was *American Big Game Fishing*, a collection of writing on bluewater fishing edited by Connett. Hunt worked on that book from the outset, writing, selecting pictures, drawing maps and providing art.

But the second Derrydale book Hunt illustrated that year, a warm and quirky collection of grouse and woodcock hunting essays by Burton L. Spiller, proved a matter of fate on many levels. Hunt, a last-minute replacement artist, seems never to have met Spiller, despite ultimately illustrating four of his books. Ironically, the work Hunt did for Spiller's Derrydale books are among his best-known—and most beloved—drawings.

On June 21, 1933, Connett wrote Spiller in care of *Field & Stream*, praising a recently published hunting story by Spiller, "His Majesty the Grouse." Connett said he would like to publish a grouse book by Spiller, perhaps under Derrydale's new trade book division, Windward House.

Spiller enthusiastically responded from his home in East Rochester, New Hampshire, saying he had already begun putting together material for just such a book. "What I had planned was a work taking up the various phases of grouse hunting and allotting to each a definite place in the story, illustrating each angle with an anecdote or two and enlivening the whole with humor of the repressed variety" (from correspondence between Spiller and Connett in the Derrydale Archives).

The publisher responded promptly and positively, suggesting Spiller include woodcock shooting as a means of broadening the book's sales appeal.

By the end of December, Connett had the completed manuscript and warm wishes from Spiller: "My very sincere thanks are due you for suggesting it, for I have

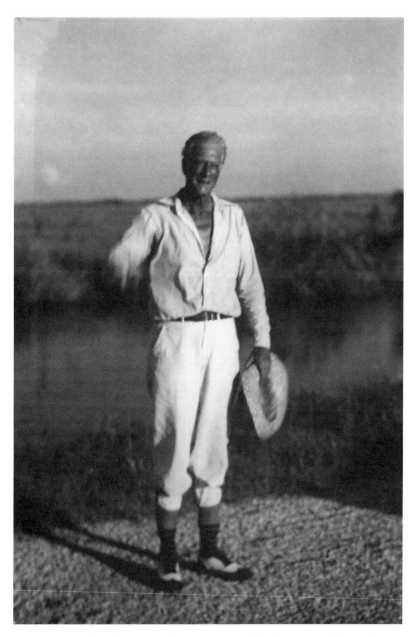

Lynn Bogue Hunt, ca. 1940. Photo courtesy of Milton C. "Bud" Weiler, Jr.

found it to be the most interesting bit of work I have ever done" (correspondence between Spiller and Connett in the Derrydale Archives). Connett promised to read it quickly and get back to the author.

But Connett waited until June 1934 to respond about the book Spiller had already dubbed *Grouse Feathers*.

He told Spiller he liked the book and wanted to print it, but only established authors were selling during the Depression. Connett suggested holding the book back until the market improved. He also wanted to market it as a limited edition book selling for $7.50 a copy because grouse hunting itself is geographically limited, but grouse hunters are "great enthusiasts" who would pay more for a book about their pursuits. Connett offered to return the manuscript if Spiller wanted to place it elsewhere.

Spiller stuck with Derrydale and Connett decided to proceed. He lined up John Frost, son of noted sporting artist A. B. Frost, to illustrate the book in a December 24, 1934, letter accompanying a copy of the manuscript.

Jack Frost wrote back to Connett two days later to say it was "beautifully written" and "perfectly bully" and he hoped to "make a go of the illustrations." But Frost also reported that he had nearly destroyed the manuscript—the only copy Derrydale had—when a bottle of homemade wine broke and seeped into about 50 pages. A few weeks later Connett asked Spiller to send scenery and hunting photographs directly to Frost, who lived in Haverford, a suburb of Philadelphia. Spiller wrote back, promising to assist Frost.

Frost, known for his beautiful California desert scenes, never had the chance to work on Spiller's illustrations. Recurrent tuberculosis sent the artist back to California in the summer of 1936; he died the following June.

Undeterred by Frost's illness, Connett sent Spiller "that fearful instrument commonly known as a publisher's contract," on July 2, 1935, suggesting that the book would likely cost $20 and be limited to just 750 copies. The publisher also told Spiller that Hunt would substitute for Frost: "Unfortunately Mr. John Frost has developed tuberculosis and of course cannot illustrate the book; but I have been talking to Lynn Bogue Hunt about it. Mr. Hunt does some remarkably fine work privately—much better than what you see in *Field & Stream*, and we are planning a series of delicate pencil drawings featuring birds and dogs, with backgrounds in a lower key" (from correspondence between Spiller and Connett in the Derrydale Archives).

Later that month, Connett wrote to say the book would instead sell for $10—about $130 in today's dollars—because the market remained weak. He told Spiller in August he hoped to have the first Hunt drawing in hand very soon.

Connett called Spiller "the Perfect Author" in an early October letter because "You haven't bothered me once since we started your book." Already 500 copies were on order, his publisher informed the author. By late October, Spiller was signing finished copies of the book. His letter to Connett makes clear he had never met or corresponded with Hunt: Spiller asked for the artist's address. "I would like to send him a note of appreciation" (from correspondence between Spiller and Connett in the Derrydale Archives).

The book—ultimately 950 copies—sold out by the end of December.

Over the next two years Connett published two more titles written by Spiller and illustrated by Hunt in the succeeding years, *Thoroughbred* and *Firelight*. The books did not sell well and Connett sounded increasingly frustrated with Spiller and his works in a series of letters. In response, Spiller replied that Hunt's art for *Thoroughbred* was not good, but the *Firelight* art was better.

Finally, Connett explained in a frank July 1937 letter that he could not afford to print any more under-performers written by Spiller. He also expressed doubts that Spiller understood Derrydale's market niche—over the years the author had repeatedly sent rejected book proposals to Connett, even suggesting a play about fishing—but the publisher remained eager for another Spiller grouse book: "I'll publish as many *Grouse Feathers* as you can write."

Connett wrote Spiller again in November, asking if he had done any work on another grouse book. Spiller responded with interest and sent Connett sample chapters in December. That pleased Connett. He suggested the title *More Grouse Feathers*, saying it would "be a good selling title."

By March 1938, proofs were sent to Spiller, and Connett happily reported the new grouse title was "leading all the others on our spring list in advance sales." He also reported: "Lynn Bogue Hunt has done a grand set of drawings for the book" (from correspondence between Spiller and Connett in the Derrydale Archives).

It was the last book Hunt illustrated for Derrydale and also the last book of Spiller's the publisher printed; Connett rejected a Spiller manuscript in 1940 and their correspondence ended. Connett's publishing house closed down a short time

later when it became clear that acquiring the supplies he needed to produce quality books would be impossible during WWII.

The Derrydale Archives show Hunt not only profited from royalties earned by his Derrydale books, but he also split the money Derrydale made reselling his publishing artwork to the Sporting Gallery & Bookshop. His Derrydale drawings wholesaled for as little as $20 to as much as $50 in 1936—about $260 to $650 today. Hunt also sold his art directly to the Sporting Gallery and Bookshop, Inc. and to Abercrombie & Fitch, both in New York. Later, he also sold his artwork to The Crossroads of Sport, also in New York.

Derrydale and gamefishing provided Hunt's introduction to novelist Ernest Hemingway. On October 19, 1933, Hunt wrote to "Mr. Ernest Hemingway," in care of Scribner's, his New York publisher, inviting the author to participate in a December fishing tournament sponsored by the Key Largo Angler's Club. Hemingway's response was lost or discarded—Hunt was not much of a saver of letters, ledgers or other documents. But Hunt's next letter showed that while Hemingway declined, the young novelist had responded in some detail to the artist's invitation.

Hunt's November letter to the author began with the artist expressing hopes that Hemingway would consider participating in the tournament next year and then alluded to the author's plans for an African safari. It went on to lavishly praise Hemingway's work and fishing accomplishments:

> I envy you your projected trip to Tanganyika. I have always been crazy about Africa and had been selected by the late Carl Akeley to go to Africa as a painter for the Natural History Museum here, on the trip scheduled for the winter during which he died.
>
> I do not think there exists anywhere a more ardent admirer of your virility and power as a writer than myself, and it is my hope that when you return to the States you will give me the opportunity of making your acquaintance. Your feats with the big marlin off the coast of Cuba have excited a great deal of interest among anglers in this country and have added immensely to my admiration of your personality, where there seemed no room for admiration to grow. (From the Ernest Hemingway Collection at the John Fitzgerald Kennedy Library.)

Hemingway and his then-wife, Pauline Pfeiffer, left for a two-month safari on December 20.

The next surviving correspondence, from February 2, 1935, found Hunt writing Hemingway to discuss a Derrydale book they were already collaborating on, *American Big Game Fishing*. Connett served as the book's editor and publisher.

Hunt wrote elaborate instructions in the letter, asking Hemingway for help with some facts about sailfish guides in Key West. But most of the letter pertained to getting guides to draw pictures showing how they rig various baits in order for Hunt to replicate them in the book.

The letter again closed with praise for Hemingway's writing and fishing accomplishments and requested an autograph on a recent magazine piece. The flattering tone in the letters is somewhat surprising; Hunt was a long-established artist and 21 years the senior of Hemingway, whose career was still young.

One of the most significant books ever written on bluewater angling, *American Big Game Fishing*, featured Hemingway writing about marlin and Hunt with a 53-page chapter on sailfish. (He loved them for their delicate color and advocated live release.) A host of other expert anglers also shared their insights. Contributors were generally paid only a token amount; the real reward was being part of this seminal book on the subject.

Like most Derrydale issues, *American Big Game Fishing* is a beautiful book, decorated with some of Hunt's most successful saltwater fishing scenes; Connett thanked Hunt for his work in the introduction. Just 850 copies were issued. Today, it is one of the most sought after and valuable books illustrated by Hunt.

Hemingway left Key West on April 14 to fish nearby Bimini. Hunt sent him a letter on June 26 and it is clear they had fished Bimini together by then. Hunt wrote the letter in longhand—he customarily typed letters—on cruise boat stationery, evidently sent as Hunt sailed back to New York. The address simply read "Mr. Ernest Hemingway, Cruiser 'Pilar,' Bimini, Bahamas, B.W.I." The letter arrived in Bimini on July 7.

In the correspondence, Hunt talked about photographs of Hemingway that were for illustrating the fishing book. He also invited Hemingway to visit anytime he came to New York.

There are pictures from that time in Bimini, showing Hunt, shirtless, but still wearing a beret on his snow-white head of hair, puffing on a cigarette as he and Hemingway admire a marlin landed by Tommy Shevlin, a noted angler of that time.

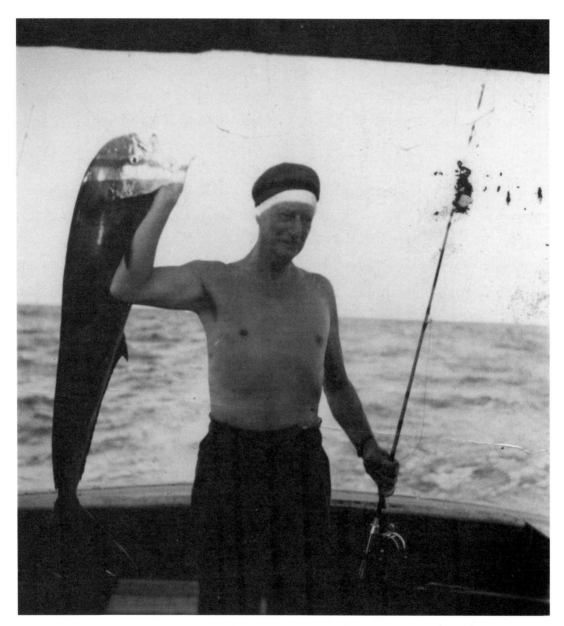

Lynn Bogue Hunt with a bull dolphin fish, ca. 1940. Photo courtesy of Milton C. "Bud" Weiler, Jr.

Another picture from the same period shows Hemingway and a marlin caught by Farrington, who probably accompanied Hunt on the Bimini trip.

On July 22, Hunt wrote again, telling Hemingway their book, *American Big Game Fishing*, pleased him. He expressed hope the book satisfied Hemingway, too. He also reminded Hemingway about several photographs he wanted for his own use, including one of Hemingway with a lion he had killed while on safari.

He also apologized for the intrusion on Hemingway's time: "I think my studio is run much the same way as your writing establishment in Key West—that is, it is strictly a one-man job and the details, outside of getting the job done, are a terrific pest and very hard to accomplish."

The letter concluded with hope the two would see each other again in August. (Hemingway actually went to New York for a month beginning in mid-September to see a bout between boxers Joe Louis and Max Baer and also meet with his editor, Maxwell Perkins. Hemingway's *The Green Hills of Africa* came out later that fall.) Hunt told Hemingway that the New York fishing fraternity planned to throw a party for the author. The artist also informed Hemingway that he intended to show film he had shot of the *Pilar* and her crew at the gathering.

Hunt sent a letter (which is the final surviving correspondence from the artist to Hemingway) on February 1, 1936. The letter thanked Hemingway for several photos and also mentioned a newspaper story about Hemingway that Hunt had yet to read. Hunt added that he could still get a copy from Farrington.

Later that year, Hemingway bought a copy of Hunt's book of bird drawings for Derrydale, *An Artist's Game Bag*. In Hemingway's judgment, Hunt was "the finest painter of gamebirds we have in America." Many sportsmen still share Hemingway's opinion of Hunt's work. The book contains Hunt's brief observations and reminiscences, including mourning the extinction of passenger pigeons due to overhunting. It fetched $125 a book for the deluxe edition of 25 copies and $12.50 for a regular edition of 1,225 copies. That would be about $1,625 and $162 today. Collectors respectively pay $6,000 and $350—and up—for those books now.

According to Hunt's family, the artist also visited Hemingway in Key West and later in Cuba. Hemingway moved there in the spring of 1939 with his then-girlfriend Martha Gelhorn, who eventually became his third wife. Hunt apparently painted a picture of the novelist's pet quail, perched on a sofa in Finca Vigia, his Havana home.

The original pencil drawing used as one of the illustrations in An Artist's Game Bag,

published by The Derrydale Press in 1936. Image from a private collection

The original pencil drawing used as one of the illustrations in An Artist's Game Bag, *published by* The Derrydale Press *in 1936. Image from a private collection*

TO MAURICE WERTHEIM—
SPLENDID HOST!

LYNN
BOGUE
HUNT

An original pencil sketch presented by Hunt to Maurice Wertheim, noted Long Island sportsman and author.

Image from a private collection

Hunt's mistress, Irene Severs—not his wife—accompanied Hunt on those trips, according to his family. Details about Irene Severs are difficult to find. But everyone who counted knew about his relationship: his editors and the larger world of New York publishing, art and advertising knew; his friends and patrons knew; his sons knew; and most of all, his wife, Jessie Bryan Hunt, knew.

How and when Hunt came to know Severs is unclear. One of the earliest documented acknowledgment of Severs by Hunt is 1939, the year Hunt designed the sixth Federal Duck Stamp, a pair of green-winged teal sitting on a marshy bank with a group of four more teal buzzing by in the background. Hunt originally did the sketch in pencil. Another artist executed a stone lithograph copy of the original. The lithographic prints were issued at $12. Hunt also made duplicate drawings of the teal, probably 15 in all, which were numbered on the back. They sold originally for $75 each, a huge sum at the time. He warmly inscribed one for Severs.

A May 1941 letter on Hunt's letterhead begins familiarly, "Irene reminds me. . . ." The letter ends with "Lynn" and "Irene" in two distinctly different hands, making it clear they were sending salutations as a couple.

Members of Hunt's family say the relationship between the artist and Irene Severs lasted at least 20 years. Severs, who lived on High Street in Jersey City into the 1970s, also signed her name as Mrs. J. Frederic Severs.

While Jessie Hunt had no interest in Hunt's outdoor pursuits, Severs routinely accompanied Hunt to country shoots and often went with him on fishing trips, especially to Florida, according to his family. Florida's Boca Grande Hotel, a sturdy three-story brick building, opened in 1929. The resort drew wealthy northerners intent on the area's fine tarpon fishing. And in order to attract high rolling guests, managers of the hotel invited Hunt—and by extension Severs—to stay at the resort gratis. In late winter or early spring, Hunt and Severs would board a train at Grand Central Station and eventually end up at the terminus of the Charlotte Harbor and Northern Railroad in the well-heeled village of Boca Grande. At the hotel, Hunt would paint, fish, tell stories and dine with guests, some of whom bought his work. In return, the hotel generated a buzz and raised its profile through Hunt's notoriety.

Some years, while Hunt was off to Florida with another woman, Jessie Hunt would drive alone to Florida, staying by herself or with her grandson; she and young Boguie stayed at the New River Inn in Fort Lauderdale in the spring of 1944. Hunt sent certified checks to pay for their room and board.

Christmas Card, 1936. Charcoal on white board.

From the collection of Paul Vartanian

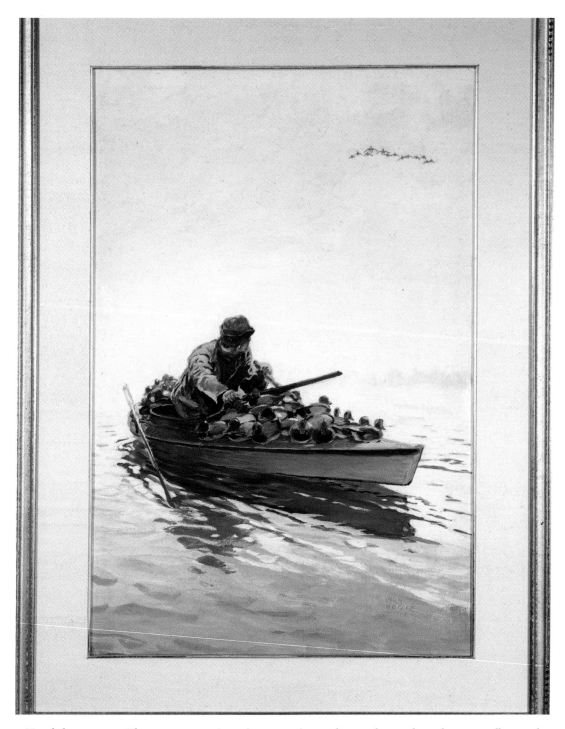

Untitled, ca. 1940. This painting was from the estate of Dr. Edgar Burke. Burke and Hunt co-illustrated
Duck Shooting Along the Atlantic Flyway. *Oil on canvas.* From the collection of Paul Vartanian.

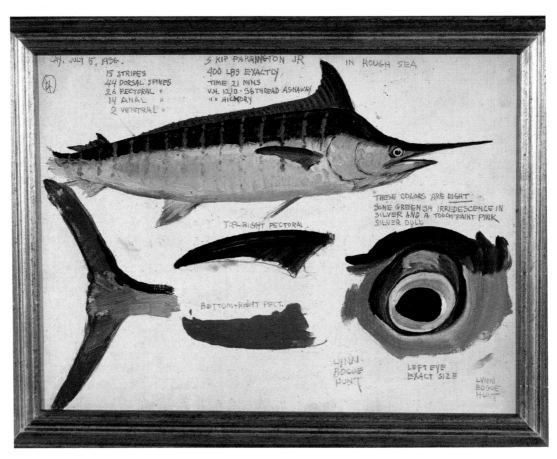

A study done by Hunt. A great example of how he tried to get coloration correct. Done off Cat Cay in 1936 with S. Kip Farrington. Oil on board. From the collection of Paul Vartanian.

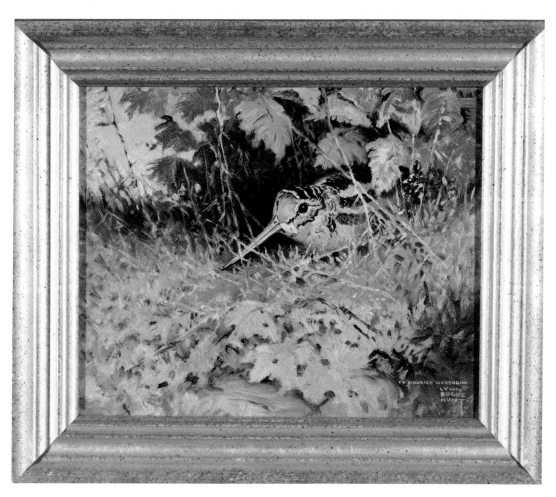

Woodcock, ca. 1930's. Oil on canvas. From the collection of Paul Vartanian.

Pheasants. From the collection of Paul Vartanian.

Quail, 1948. Oil on canvas in original frame. From the collection of Paul Vartanian.

Shallow Water Ducks. One of the twelve images for 1946 series "Game Birds of America." Oil on canvas.
From the collection of Paul Vartanian.

Old George & Tommy. *Pencil drawing appearing in* Thoroughbred *by Burton Spiller, published by*
The Derrydale Press in 1936. From the collection of Paul Vartanian.

"Xiphy—A Big Boy Now—Meets Up Senorita Albacora, La Chica Caliente." Ink on board, 1942. Used as

an illustration in S. Kip Farrington's Bill, the Broadbill Swordfish, *published in 1942.*

From the collection of Paul Vartanian.

Spider & Wasp. *Watercolor*. From the collection of Paul Vartanian.

White-throated Sparrows, 1928. Watercolor. From the collection of Paul Vartanian.

Turkey. Cover for Field & Stream, *November, 1938. Oil on board. The actual cover included a hunter, which the artist later painted over. From the collection of Paul Vartanian.*

Hawk attacking wood ducks. Guache on board, ca. 1915 to 1920. From the collection of Paul Vartanian.

Sandy Island, Barnegat Bay, New Jersey. Used as one of the illustrations in Van Campen Heilner's A Book on Duck Shooting, *1939. From the collection of Paul Vartanian.*

A Christmas Deer. Field & Stream, *cover, December, 1937. Oil on canvas.*

From the collection of Paul Vartanian.

Severs never spoke publicly about her relationship with Hunt; she admitted in writing a decade after he had died that she and Hunt were "good friends."

But Hunt's high-profile affair with Severs caused frequent friction in the Hunt household, according to Hunt's family. It drove his youngest son, Bryan, away from home at a young age and he seldom returned to visit due to his discomfort. Hunt and his wife often quarreled during their middle years.

On the surface, Hunt's wife seemed to those who met her only occasionally or in her later years to be a deferential family-centered woman, the anchor who lived in the background of her husband's large shadow.

The reality is far different, though. Headstrong and brash, she drove herself from Long Island to Florida and back in the 1940s. "She was very much not a wall-flower," recalls her grandson, Lynn Bogue Hunt III, who as a teen sometimes accompanied her on trips to Fort Lauderdale's New River Inn.

Indeed not, according to family stories. When she got into an auto accident once in New York, she and her oldest son got out of the car to examine the damage. When the other driver approached, she belted him over the head with a high-heeled shoe, snapped "Get back in the car Bogue!" and sped away. (From a February 2000 interview with Marilynn Hunt Guzelian.)

She thought nothing of pulling a ribald stunt on a passed out guest at a drunken party. She cared not a whit for Hunt's social circle and sporting friends, referring to them as "Hemingway and them." New York's list of 400 social elite included Hunt, but not his wife.

Despite a year of business college, her writing could be ungrammatical and she had little interest in intellectual pursuits. She did not care for either of her daughters-in-law and often picked fights with them, though she doted on their children. "She lived for the child," recalls one daughter-in-law, Doreen Hunt, widow of Bryan Hunt. "During the Depression she dressed Boguie in outfits from Lord & Taylor.

"Lynn was in another world. There might be some of that, a worry that she would hold back or embarrass him. Jessie wasn't as sophisticated as Lynn. I can understand why; he was with Hemingway and Lerner, hunting and fishing and Jessie had two children and she wasn't interested. Jessie didn't grow up. He lived in two worlds; he had a separate life," remembers Doreen Hunt of her in-laws.

"She was a character," sums up Jessie Hunt's granddaughter, Marilynn Hunt Guzelian, who lived with or near her grandparents on Long Island throughout her childhood.

Enough of a character to instigate her eldest son, Lynn Bogue Hunt Jr., to burn down one of the family's homes, according to one family tale.

While Hunt had no interest in architecture and furnishings, a series of moves to increasingly upscale addresses in Sea Cliff, Glen Head, Glen Cove and Garden City, Long Island, marked his economic progression. Their Garden City home, paid for by a 450 square foot mural he did at a Baltimore hotel, clearly told the world Hunt had made it. Unhappy with old furniture in their Garden City home, Jessie had Bogue build a small smoky fire, meant to make the furniture stink enough so that Hunt would spring for new furnishings. But the "housewarming" fire burned out of control, destroying the home along with Hunt's collection of shotguns and fine fishing tackle.

As punishment, Hunt angrily moved his family to 41 Temple Street in Williston Park, a decidedly less-desirable location where the Hunts lived until he died. Wood-framed, three stories, nondescript: Hunt meant the simple home as punishment for Jessie. Ironically, it became the place where Hunt remained largely confined by infirmities during the last decade of his life.

It is unclear if Jessie ever met Irene Severs. But Hunt's wife clearly knew about his mistress, and often complained and fought with her husband about his affair, according to family. Perhaps the separation of his own parents played a role in keeping Lynn and Jessie Hunt living together, though apart.

Despite their long-term strife, Jessie Hunt nursed her failing husband through his last years.

Chapter Six

The Final Years

The 1940s began as an active decade for the 62-year-old Hunt, with continued hunting and fishing trips, magazine covers, magazine portfolios, book illustrations and private commissions.

At the height of his recognition and popularity, the dean of American sporting art became increasingly commercialized, producing Christmas cards for Hallmark; nature cards for Coca-Cola; collectors' stamps for the National Wildlife Federation; and coasters, glassware and plates with images of fish, game animals and horses on them.

Barely noticeable at first, the quality of his work clearly eroded as the decade progressed. Increasingly, his style loosened, a change that began in the mid-1930s but accelerated rapidly in the 1940s. Impressionistic backgrounds and other fine details disappeared. Complex design and composition slipped away. His once vibrant use of dimensional color initially turned flat. Later, his pictures became dark and muddy.

The commonly accepted explanation for the changes is that Hunt had simply overextended himself, taking on too much work he did not care for in exchange for the money, not the artistic rewards.

There is some truth to that; Hunt had a reputation for accepting every job of-
fered, then putting more—or less—effort into the work depending on how much—or
little—the commission paid. He needed the money to feed his lifestyle.

"He lived life big, and to do that he had to make and spend money," explains
sculptor Dale Weiler, who grew up visiting Hunt with his father, painter Milt Weiler.
"He loved it and other artists were very envious. He loved gunning and fishing with
affluent sportsmen. It was an incredible crowd and a fascinating experience to play
with these high rollers. The artists of that time, what they had, they spent and what
was left was the paintings" (interview with Dale Weiler, February 2002).

But there is an underlying reason for changes in Hunt's art more fundamental
than the need for money: Hunt was going blind.

The artist, perpetually tanned from the months on end he spent outside every
year, never wore sunglasses. He told his family he was losing his vision because of "a
UV burn." Overexposure to ultraviolet light is a contributing factor to cataract for-
mation, the clouding of the eye's lens. It also may be a factor in macular degeneration,
the deterioration of the retina, which obliterates central vision. It is unclear which
condition afflicted Hunt: it is possible that he had both ailments simultaneously.

Bud Weiler, who as a child frequently visited in Hunt's Williston Park home,
says Hunt "clearly couldn't see" at the end. But trouble with fading eyesight began be-
fore that and it showed in Hunt's art.

"There was a starkness to the paintings, a lack of dimension. The brilliant
color was there, but the subtlety of design was going" (interview with Bud Weiler,
March 2002), recalls Weiler, another son of artist Milt Weiler, whom Hunt had men-
tored.

His production of *Field & Stream* covers slowed, doing just three a year be-
tween 1943 and 1946. There were four covers in 1947, and then not a single cover in
1948.

Fittingly, the last two *F&S* covers were of waterfowl. There were Canada geese
in 1949. Nothing in 1950. And finally, a flight of mallards in October 1951, the same
year he turned 73 years old. Hunt did his last duck hunting the following year on Long
Island.

The artist increasingly worked at home, rather than commuting to his stu-
dio, an inner sanctum that remained off-limits to most of his family. He increasingly

Lynn Bogue Hunt at about age 80. Photo courtesy of Ann Farley Gaines.

depended on his wife to ferry him to and from the train station as he drove less and less.

As his world grew more circumscribed, Hunt received fewer guests and he did not see Severs in his final years, according to family. Besides his relatives, his main visitors were equine artist Paul Brown and Weiler, an artist best known for duck hunting and fly-fishing scenes. Both lived nearby on Long Island and they formed a supportive community for Hunt; Weiler named his daughter Lynn in honor of his mentor; Lynn Weiler Campbell's godfather was Paul Brown.

In the early 1950s, Hunt began producing small paintings at a furious pace, sometimes completing a work a day. The colors were flat and predominately brown; the subject invariably birds, according to family. Weiler helped him catalog paintings and ready them for sale, assisting him in shakily placing his nearly illegible signature on the painting. Hunt, who had never saved cash, desperately tried putting money away for his retirement, even cashing in life insurance policies.

He stopped painting altogether sometime between 1953 and 1954.

Hunt celebrated his 80th birthday in 1958 with a circle of friends from *Field & Stream*. Among them were fishing whiz and writer A. J. McClane, adventurer and writer Robert Ruark, art director Herman Kessler, and several artists, including Tom Rost and Bob Kuhn. They met at the Williams Club, 29 East 39th Street, which doubled as the home of the Theodore Gordon Flyfishers Club. Even though some of the men from *F&S* had never worked with Hunt at the magazine, they all knew and respected his art; Tom Rost recalls, "He wasn't doing any work by then, but he was a delightful man" (interview with Rost, April 2002).

But most of his latter years were confined to the rhythms of family life. One of his last large canvases, a pair of whooping cranes, went to a visiting grandniece following the rare privilege of sleeping in his studio, where the unfinished work had hung. The birds in the unsigned painting do not have eyes; Hunt could not see well enough to finish fine details.

Toward the end of his life Lynn and Jessie Hunt drove from their home in Williston Park to Lynn Bogue Hunt Jr.'s home in Cold Spring Harbor every Sunday for a big 2 p.m. dinner.

Hunt made what became his final request on Thursday, October 8, 1960: He asked his wife to take him to the Oyster Bay, Long Island home of President Theodore Roosevelt, an outdoorsman and conservationist.

Lynn Bogue Hunt, ca. 1950. Photo courtesy of Milton C. "Bud" Weiler, Jr.

"Lynn was a great admirer of T. R. and had often wanted to go there," Jessie Hunt wrote in a letter to her sister-in-law, Lena Farley. "Twice before I have taken him to the house, but neither time could we get in. Roads were being repaired or it was a holiday. So he asked to go. I just couldn't refuse although I thought it quite an undertaking.

"Well, he was so tired he couldn't go about, but we found a seat and I roamed about and then would tell him and he would send me back to look at something else that he wanted me to tell him about.

"Well, we got back home and he was quite happy with our trip. But after that he was so tired. On Sunday, he was running a temperature and I sent for the doctor and I was told to keep him in bed. (Try and do it!)"

Jessie went on to explain her difficulties caring for her now-invalid husband: "for some time past he has been turning day into night and sleeping all day and up or wanting to be up all night" (letter from Jessie Hunt to Lena Farley in possession of the Farley family). She had trouble moving him by herself and had no luck trying to get a home nurse to their house. Hunt developed pneumonia, became dehydrated, and his kidneys began to fail. The doctor sent him to Nassau Hospital in Mineola, the county seat. By the next afternoon Hunt could not recognize his wife of 57 years. He died at 1:30 a.m. on October 12.

Jessie Hunt wrote Lena Farley, his sister, that Lena's visit shortly before Hunt died had made him happy. She also alluded to Hunt's lack of fidelity and said she forgave him.

"As he told you, I think he was happy. I hold not hard feelings for neglect, only love, and I am so glad I could help in his years of need.

"I do not know my plans. I must take time to care for myself. I will have to sell this place, as there was no insurance; he cashed in the two he took out when the boys were born. But I will manage. I always have and our Father will not leave me without necessities. I have never wanted anything I couldn't get if I trusted Him.

"My faith is stronger than ever to live and do all the good possible. You will hear from me when I am not so tired. Just know, Lena, that Lynn is at rest peacefully and know that he is happy" (letter from Jessie Hunt to Lean Farley).

The *New York Times* October 13 obituary called Hunt "the Audubon of his time." Telephone calls and letters "from all over the county from people I never heard of" overwhelmed Jessie Hunt. Jessie requested a simple and dignified ceremony. Hunt returned one last time to Michigan for interment at Woodmere Cemetery in Detroit.

Hunt's sons, Bryan and Bogue, went to his Manhattan studio a few days later to retrieve their father's remaining art for their mother.

The studio was empty. A watchman explained that a woman who called herself "Mrs. Hunt" had let herself in.

She cleaned out the studio.

Chapter Seven

His Work

As with his life, there's a dichotomy to Lynn Bogue Hunt's work. While he lived, Hunt's prolific commercial work made him extremely popular. The demand for his work in turn drove him to be more prolific. But today his prodigious body of work places him just behind the front rank of sporting artists.

Ironically, Hunt's sometimes-brilliant artwork is overwhelmed by the sheer quantity of his often so-so commercial output. Over all, Hunt is considered a first-rate sporting art illustrator and a good outdoor artist. Had he used his unquestioned fame and ability to more selectively create fewer higher quality works instead of relying on volume and quick sales, the critical assessment of Hunt's career may have reversed.

Hunt's best work realistically captured moments of drama between men and their prey. But his illustrations frequently followed a repetitive formula. For instance, he repeatedly turned out paintings depicting various species of gamebirds fleeing a gunner and flying directly toward the painting's viewer, with the hunter in the background swinging a shotgun toward the birds—and by extension at the viewer. Effective and dramatic as an illustration, it did not break new ground as art and became something of a stock cliché in Hunt's repertoire. Likewise, his gamefish

paintings repeatedly depict the same sea level perspective, showing a fish jumping in the foreground as a boat slides down a wave in the background while half-seen fishermen reel furiously. And some of his illustrations have a rushed, almost cartoonlike quality, good enough to illustrate a story—but not good enough to be great art. Still, his best work clearly stands the test as art and sportsmen cherish his illustrations as evocative reminders of time afield.

Hunt's modest view of his skills may have prevented him from making the transition from master illustrator to master artist. "I don't have the sense that L. B. H. ever felt he had a great deal of stature," recalls his granddaughter, Marilynn Hunt Guzelian, who lived with or near her grandfather during most of the last two decades of his life (from a March 2002 interview). "He was a good artist, not a great artist, and he felt very lucky to be able to make a good living at what he loved to do. He loved his work; felt very blessed that his life's work was something that he loved so very much and very, very lucky that he found the talent to be able to earn a living doing what he loved" (from a February 2002 interview).

Asked by a relative about his humble opinion of himself as an artist, Hunt explained: "About my 'Modesty' or 'Humility,' it is my observation only those who have stopped learning about themselves and their work or those who are insecure ever get swelled heads. That is the greatest stupidity in the world. Life is short and Art is long and no one ever lives long enough to be able to say, 'I have arrived at perfection'" (from a 1945 letter).

Hunt's artistic models were not his contemporaries in the realm of commercial illustration or even the best sporting artists of his time. Instead, Hunt admired the great landscape painters of his time: Winslow Homer—Hunt owned a seascape by Homer, an illustrator before taking up gallery painting late in life—and Bruno Liljefors.

Hunt believed that Liljefors, an artist whose stunning landscapes are little known outside his native Sweden, was the only wildlife artist to ever achieve perfection. "He made the greatest contribution to wildlife painting of any man," Hunt wrote, "and since he achieved perfection it follows that there will never be his superior" (from the 1945 letter).

Hunt treated painting as a job, not a calling, which may explain why he never embraced the risky but rewarding gallery painting done by Homer and Liljefors.

But what Hunt did well—outdoor illustration—he did very well. He is one of the top American outdoor illustrators ever, according to author and art dealer Walt

Hunt with one of his few sculptures. Photo from the collection of Paul Vartanian

Reed. "He was a dominant figure," says Reed, coauthor of *The Illustrator in America.* "Whenever a magazine wanted an outdoor theme, they turned to him" (April 2002 interview).

"There's the question of so-called fine art versus so-called illustration," says Reed. "Fine art and illustration can be the same thing. With Hunt, [the pictures] are all about art, but not all of his pictures are at the same level."

Hunt's unevenness comes from his tendency to accept all commissions, whether they interested him or not, and to put as much—or as little—into them as he got paid. "He painted what he was paid to paint, versus what works best," says sporting art dealer and collector Tim Melcher (from a June 2001 interview). "If you paid him $30, you got a $30 painting; if you paid him $300, you got a $300 picture. But no one painted feathers like he did. He was popular and realistic."

However his work is labeled, Hunt had an uncanny ability to tell a story with a picture, according to sporting book dealer Carol Lueder. "That's what made him

popular: his pictures told a story and that's why people remember him" (from a July 2001 interview).

Working primarily as an illustrator did not prevent Hunt from creating enduring work. "Some of the best artists today began as illustrators," notes art dealer and collector Russell A. Fink, who has two Hunt bird paintings in his personal art collection. "Lynn Bogue Hunt was good at that. His paintings have confident strokes; that tells a lot about the artist. He was a major figure. He made the bridge from illustrator to fine art" (from a March 2002 interview). "He was much stronger on birds and dogs. His fish are dated and stylized, his mammals stiff," says Fink, an opinion shared by many experts.

Writer George Reiger enjoys the period nostalgia evoked by Hunt's gamefish paintings depicting bluewater fishing's Golden Age, but he says Hunt was not accomplished at capturing realistic "wet fish"—Hunt's fish appear as though they were added to the work, as indeed they were, with Hunt painting them in separately from the boat and waves in the painting's background (from a July 2001 interview).

Hunt told his grandson, Alan Bryan Hunt, that his masterful depiction of birds came from observation and familiarity: "I know how the birds act. I've been there. I've seen them. I know," the aging artist told Alan Hunt while he was still a small boy (from a February 2002 interview).

Hunt's editor at *Field & Stream*, Hugh Grey, believes Hunt's waterfowl illustrations are the artist's best work (from an April 2002 interview). Artist Chet Reneson agrees. Reneson also says it does not matter if Hunt's work is labeled as art or illustration: either way, Hunt was an excellent bird painter. "It doesn't make a bit of difference, illustration versus art. A painting is a painting. There's good art and [bad] art and good art means doing the best you can do when you do it," says Reneson, who began his career as an illustrator. "He was a great bird painter. He painted birds better than most artists today. What I liked about him, when he drew or painted a pheasant it looked like what it was supposed to be. He got the character of the bird, the feel of it, without overworking the painting," says Reneson, who grew up on a gamefarm (from a February 2002 interview).

"There's a lot left out in his paintings, less is more and abstraction is better," which makes Hunt's work true art, says Reneson, who hates the photo-realist artwork popular in recent decades.

As a youngster, Reneson traced copies of Hunt's birds onto his own early artwork, especially Hunt's illustrations for Van Campen Heilner's *A Book on Duck Shooting*. Reneson recalls that the pages of the book were worn and falling out because he looked at and copied Hunt's artwork so often. "His work was overly colorful; he wasn't afraid of that. The greatest compliment to a painter is that you know who painted it whether it is signed or not and you can tell his work. You can tell his work. I always admired his covers," says Reneson.

Dale Weiler, a wildlife sculptor and the son of wildlife painter Milton C. Weiler, one of Hunt's best friends, unabashedly admires Hunt's eye-catching illustrations and believes that his work is underappreciated. "He is really best known for his illustrations and not for his art. Lynn was known for his bright colors and his commercial work. If you look at a lot of Lynn Bogue Hunt's work it was really vibrant. He has slipped through the cracks" (Winter 2001 interview).

"He painted what he loved, from field experience," says Weiler. "He was not trying to capture every detail, but the feel, the essence of it. All of the outdoor artists back then were sports. They all walked the walk. That's where they got their inspiration."

The bright colors Hunt is known for were a by-product of working as an illustrator when print reproduction was unreliable, according to Walter Reed. "One of the requirements of the illustrator was to force the color contrasts because reproduction softened and muddied the picture," says Reed. "They compensated in advance" (from an April 2002 interview).

While all of his early art training was from academic classicists, his style and use of color evolved quickly once he moved to New York in 1903.

The October 1905 edition of *Outing* magazine contains three illustrations by Hunt, all of different styles: a pair of shovelers depicted in a formal style clearly influenced by John James Audubon (Hunt wrote in his unfinished autobiography that he saw Audubon's popular works while a young man); a conventional modern magazine style depicting decoy carvers at work; and finally his signature dramatic look showing a hunter with a springer spaniel flushing a trio of wood ducks.

"He was probably influenced by the prevailing artistic tendencies of that period," says Reed, an expert on illustration. "When he began, his work was tight, controlled, realistic, like classic academic painting. As time went by, impressionistic color influence was evident" (from an April 2002 interview).

Whether his work is seen as art or illustration, Hunt's distinctive style—a unique mix of drama, bright color, detailed action, impressionistic backgrounds, even his bold stacked signature—marks him as an American original valued by collectors and sportsmen alike who appreciate his ability to accurately distill and then capture a fleeting moment forever.

Appendix of the Artist's Work

Portfolios, Stamps, Cards and Prints

1917

"Our American Game Birds" Wilmington, Delaware: E. I. duPont deNemours & Co., Inc., 1917. Chromolithograph. 18 color prints with descriptive text by E. H. Forbush. Edition size unknown.

1. Bobwhite
2. Brant, black brant
3. Canvasback, redhead
4. Dusky grouse, ruffed grouse
5. Gadwall, shoveler
6. Goldeneye, white winged scoter
7. Greater yellow-legs, golden plover, black-bellied plover
8. Mallard
9. Mountain quail, California quail
10. Pintail, black duck, baldpate

11. Pheasant

12. Scaup

13. Upland plover, Hudsonian curlew

14. Virginia rail, clapper rail, king rail, coot, sora rail

15. White-fronted goose, greater snow goose, Canada goose

16. Turkey

17. Wilson's snipe

18. Wood duck, green-winged teal, blue-winged teal

Also see related book entry below by Edward Forbush. Many of these prints also appeared on the cover of *American Shooter* during 1918 (see page 69).

1929

American Shooting Scenes, "Quail," New York: The Derrydale Press, 1929. An aquatint executed by artist Edward King from an original Hunt drawing. Edition of 250 numbered and signed prints.

1939

"Green-winged Teal" Federal Duck Stamp, 1939–40. 1,111,561 copies of the Migratory Bird Hunting Stamp with an LBH illustration were sold by the U.S. Department of Interior. Also a Duck Stamp print in two editions of 100 each.

Wildlife Postcard Series. A set of 8 postcards published by the National Wildlife Publishing Co., 1939. The set included five mammals and three ducks.

1940

Hunt contributed to a Wildlife Postage Stamp Album including 25 stamps.

1944

"Game Birds of America," New York: Field & Stream Publishing Co., 1944. A set of 12 photo-mechanically produced color prints.

1. Pheasant December, 1943

2. Canada goose, brant and pintail January, 1944

3. Shallow-water ducks #1 February, 1944

4. Mourning dove and bobwhite March, 1944
5. Shallow-water ducks #2 April, 1944
6. Lesser geese May, 1944
7. Diving ducks June, 1944
8. Pinnated grouse, sharptailed grouse,
 and Hungarian partridge July, 1944
9. Western quail August, 1944
10. Band-tailed pigeon, blue grouse,
 and mountain quail September, 1944
11. Ruffed grouse and woodcock October, 1944
12. Turkey November, 1944

These prints were issued as centerfold color prints in monthly issues of *Field & Stream* during 1944 and were later released as a complete portfolio. The portfolio included a booklet with descriptive text by Raymond P. Holland.

1944–1946

Christmas Cards. A series of gamebird prints and fish prints were issued as Christmas cards by Hallmark, perhaps during the holiday seasons of 1944–46. The prints, 4½" × 5½", appeared in three different sets of six prints each, including one on upland gamebirds, another on water birds, and yet another on gamefish, as described below. The gamebird set has a raised embossed color gamebird at the upper left corner outside, and when opened the center panel has a color gamebird tipped in, the left panel has information about the print and the artist, and the right panel has the holiday salutation.

Upland Game Series—Pheasant; Mourning dove and bobwhite; Pinnated grouse, sharptailed grouse and Hungarian partridge; Western quail; Band-tailed pigeon and blue grouse; Mountain quail; Turkey

Water Bird Series—Diving ducks; Lesser geese; Canada goose and brant; Shallow water ducks

Gamefish Series—Rainbow trout; Striped bass; Muskellunge; Tarpon; Largemouth bass; Billfish

"Fishing in America," New York: Field & Stream Publishing Co., 1946

1. Rainbow trout	April, 1946
2. Tarpon	May, 1946
3. Largemouth bass	June, 1946
4. Billfish	July, 1946
5. Muskellunge	August, 1946
6. Striped bass	September, 1946

With descriptive text by Ted Trueblood and S. Kip Farrington. These were issued as centerfold color prints in monthly issues of *Field & Stream* during 1946 and were later released as a complete portfolio. These six prints were also issued as Christmas cards by Hallmark in 1947.

1947
Untitled—Jumping Mallard. Publisher unknown. Ca. 1947? Stone lithograph. Signed edition of 150.

Date unknown
Hunt, L. B., contribution to a set of Coca-Cola Nature Cards, "World of Nature." Date of issue unsure.

BOOKS ILLUSTRATED BY L. B. HUNT
Note: This bibliography only describes the first edition of each title. Many were printed in later editions or printings.

Askins, Charles, Sr. (1860–1947)
Wing Shooting: For the Novice and Expert. Denver, Colo.: Outdoor Life Publishing Co., 1928. 88 pp., drawings and cover by Mr. Hunt. 16 mo. Paper wrappers. Title No. 6 in the publisher's Recreation Series.

Betten, H. L. (1873–1964)
Upland Game Shooting. Philadelphia: The Penn Publishing Co., 1940. 450 pp. with color plates and dust jacket illustration by Mr. Hunt. 8 vo. Also a deluxe edition of

124 copies specially bound in leather; this deluxe edition was published with an extra suite of the color plates appearing in the book.

Claflin, Bert
American Waterfowl: Hunting Ducks and Geese. New York: Alfred A. Knopf, Inc., 1952. 285 pp. with plates from paintings and photographs; frontispiece by Mr. Hunt. 8vo.

Connett, Eugene V., 3rd editor (1891–1969)
American Big Game Fishing. New York: The Derrydale Press, 1935. 251 pp., with many black and white and color illustrations, some by Mr. Hunt. Small Folio. This edition was limited to 850 copies. Also a deluxe edition of 56 numbered copies bound in purple leather; each of these copies contained an original drawing on the front inside cover and front free endpaper by Mr. Hunt.

Duck Shooting Along the Atlantic Tidewater. New York: William Morrow Co., 1947. 308 pp. with many black and white and color illustrations, some by Mr. Hunt. 4to. Also a deluxe edition of 100 specially bound and numbered copies; this deluxe edition was issued with an extra suite of the color plates appearing in the book.

Upland Game Bird Shooting in America. New York: The Derrydale Press, 1930. 249 pp. with many black and white and color illustrations, some by Mr. Hunt. Small folio. This edition was limited to 850 copies. Also a deluxe edition of 75 numbered copies bound in brown leather.

Evarts, Hal G. (1887–1934)
Fur Sign. Boston: Little, Brown and Co., 1922. 225 pp. with black and white illustrations by Mr. Hunt. 12 mo.

Farrington, S. K. (1904–1983)
A Book of Fishes. Philadelphia: The Blakiston Co., 1946. 88 pp. with color illustrations by Mr. Hunt. 8vo.

Atlantic Game Fishing. New York: Kennedy Bros., 1937. 298 pp. with black and white drawings and photographs; also with color illustrations by Mr. Hunt. Introduction by Ernest Hemingway. 4to.

Bill—the Broadbill Swordfish. New York: The Coward-McCann Co., 1942. 48 pp. with illustrations by Mr. Hunt. 8vo.

The Ducks Came Back; the story of Ducks Unlimited. New York: The Coward-McCann Co., 1945. 138 pp. with illustrations by Mr. Hunt. 4to.

Fishing the Atlantic, Offshore and On. New York: The Coward-McCann Co., 1949. 312 pp. with black and white and color illustrations by Mr. Hunt. 8vo.

Fishing the Pacific, Offshore and On. New York: The Coward-McCann Co., 1953. 297 pp. with black and white and color illustrations by Mr. Hunt. 8vo.

Interesting Game Birds of Our Country. Garden City, New York: Doubleday & Co., Inc., 1945. Unpaginated with color illustrations by Mr. Hunt. Oblong 4to.

Pacific Game Fishing. New York: The Coward-McCann Co., 1942. 277 pp. with black and white and color illustrations by Mr. Hunt. 4to.

Forbush, Edward H. (1899–1929)

Important Game Birds. Wilmington, Delaware: E. I. duPont deNemours & Co., 1917. 56 pp. Paper wrappers (this may have accompanied the 1917 portfolio listed above). 12mo.

Heilner, Van Campen (1899–1970)

A Book on Duck Shooting. Philadelphia: The Penn Publishing Co., 1939. 540 pp. with black and white photographs; color illustrations by Mr. Hunt. 8vo. Also a deluxe edition, limited to 99 specially bound copies. This deluxe edition was issued with an oversized extra suite of the color plates appearing in the book.

Our American Game Birds. Garden City, New York: Doubleday Doran & Co., 1941. 178 pp. with black and white and color illustrations (including dust jacket) by Mr. Hunt. 4to.

Hightower, John (b. 1901)

Pheasant Hunting. New York: Alfred A. Knopf, Inc., 1946. 277 pp. with black and white photographs; color illustrations by Mr. Hunt. 8vo. Also a large paper edition, specially bound and limited to 350 copies.

Holland, Ray P. (1884–1973)

Shotgunning in the Lowlands. West Hartford, Vermont: The Countryman Press, 1945. 213 pp. with black and white drawings and color illustrations by Mr. Hunt. Limited to 3,500 copies. 4to. Also a deluxe edition, specially bound and limited to 350 numbered copies.

Shotgunning in the Uplands. West Hartford, Vermont: The Countryman Press, 1944. 213 pp. with black and white and color illustrations by Mr. Hunt. 4to. Also a deluxe first edition limited to 250 numbered copies.

Hooker, Forrestine C. (1867–1932)
Prince Jan, St. Bernard: How a Dog from the Land of Snow Made Good in the Land of No Snow. Garden City, New York: Doubleday, Page & Co., 1921. 186 pp. 8vo.

Hunt, Lynn Bogue (1878–1960)
An Artist's Game Bag. New York: The Derrydale Press, 1936. Unpaginated with color illustrations by Mr. Hunt. Limited to 1,225 copies. 4to; dust jacket. Also a deluxe edition, specially bound and limited to 25 copies.

How to Draw and Paint Birds. Tustin, California: Walter Foster Art Books, no date. 30 pp. with black and white and color illustrations by Mr. Hunt. 4to.

Jones, Sheridan
Bait Casting for the Novice and Expert. Denver, Colorado: Outdoor Life Publishing Co., 1927. Title No. 2 in the publisher's Recreation Library Series. Paper wrappers.

Lippincott, Joseph Wharton (1887–1976)
Animal Neighbors of the Countryside. Philadelphia and New York: J. B. Lippincott Co., 1938. 272 pp. with drawings by Mr. Hunt. 8vo.

Black Wings: The Unbeatable Crow. Philadelphia and New York: J. B. Lippincott Co., 1947. 143 pp. with black and white and color illustrations by Mr. Hunt. 8vo.

The Red Roan Pony. Philadelphia: The Penn Publishing Co., 1934. 320 pp. with black and white and color illustrations by Mr. Hunt.

Lytle, Horace (b. 1894)
Gun Dogs Afield. New York: G. P. Putnam's Sons, 1942. 277 pp. with black and white and color illustrations by Mr. Hunt. 8vo. Also a deluxe edition specially bound and with an original etching by Mr. Hunt laid in and limited to 100 numbered copies.

Matthewson, Worth, editor
Wildfowling Tales, 1888–1913. Salem, Oregon: Sand Lake Press, 1989. This work is an anthology of waterfowling tales written between 1888 and 1913. Mr. Hunt authored a

single story titled "Shooting Ducks on Middle Western Ponds," which appears in this book. This article originally appeared in vol. XLVII of *Outing Magazine*.

McCracken, Harold (b. 1894)
Son of the Walrus King. Philadelphia and New York: J. B. Lippincott Co., 1944. 129 pp. with black and white and color illustrations by Mr. Hunt. 8vo.

Montgomery, Rutherford G. (b. 1896)
Broken Fang. New York: M. A. Donahue, 1935. 186 pp. 8vo.

Newell, David M. (b. 1898)
The Fishing and Hunting Answer Book. New York: Doubleday and Co., 1948. 285 pp. with black and white illustrations, some of which were done by Mr. Hunt. 8vo.

Norris, Charles D. (1876–1961)
Eastern Upland Shooting. Philadelphia and New York: J.B. Lippincott Co., 1946. 408 pp. 8vo. Mr. Hunt illustrated the dust jacket only for this book.

Rutledge, Archibald H. (1883–1973)
An American Hunter. New York: Frederick A. Stokes Co., 1937. 461 pp. with illustrations by Mr. Hunt. 8vo.

Selby, Roger A.
Arabian Horses. Portsmouth, Ohio: Selby Stud, 1937. 100 numbered copies.

Spiller, Burton L. (1886–1973)
Firelight. New York: The Derrydale Press, 1937. 197 pp. with black and white illustrations by Mr. Hunt. Limited to 950 copies. 4to.
Grouse Feathers. New York: The Derrydale Press, 1935. 207 pp. with black and white illustrations by Mr. Hunt. Limited to 950 copies. 4to.
More Grouse Feathers. New York: The Derrydale Press, 1938. 238 pp. with black and white illustrations by Mr. Hunt. Limited to 950 copies. 4to.
Thoroughbred. New York: The Derrydale Press, 1936. 200 pp. with black and white illustrations by Mr. Hunt. Limited to 950 copies. 4to.

Stock, Ralph (b. 1882)

The Cruise of the Dreamship. Garden City, N.Y.: Doubleday, Page & Co., 1921. 292 pp. 8vo.

Yeager, Dorr (b. 1902)

Chita, The Story of a Mountain Lion. Philadelphia: The Penn Publishing Company. 264 pp. with illustrations by Mr. Hunt. 8vo.

Magazine Covers Illustrated by L. B. Hunt, Including Advertisements

American Boy

1923	March	Boy collecting maple sap spots a deer
1929	September	Elephant and hunters
1930	September	Tiger
1932	September	Lion

American Magazine

1928	August	Eagle and bobcats
1929	July	Bear raiding picnic

The American Shooter

1918	January 5	Wild turkey
	February 2	Mountain quail, California quail
	March 2	Mallard
	April 6	Dusky grouse, ruffed grouse
	May 4	Wilson's snipe
	June 1	Wood duck, green-winged teal, blue-winged teal
	July 6	Gadwall and shoveler
	August 3	Greater yellow-legs, golden plover, black-bellied plover
	September 7	Virginia rail, clapper rail, king rail, coot, sora
	October 5	Bobwhite
	November 2	Upland plover, Hudsonian curlew
	December 7	Scaup

Better Homes & Gardens

1934	May	Baltimore orioles nesting
1935	March	Two robins among fruit tree blossoms

Boy's Life

1924	May	Elephant with tusks
1925	March	Native and flamingos in flight

Capper's Farmer

1934	October	Mallards

The Country Gentleman

1919	December 6	Fox eyeing a rabbit
1920	September 25	Blue heron competing with raccoon for frog
1921	May 7	Orioles building a nest
Date not known		Three wood ducks landing
Date not known		Crows and owl

The Country Guide (Canadian magazine)

193?	July	Bear raiding picnic (same cover as *American Magazine*—July 1929)
1947	September	Mallards in flight

Country Life

Date not known		Three green-winged teal landing

Delineator

1917	August	Butterflies

Farmer's Wife

1934	June	Mother bluebird feeding young
1936	May	Hummingbirds
1937	June	Red-winged blackbird

Field & Stream

In 1904 a long association between Hunt and *Field & Stream* began. It lasted over the next 46 years. During this time, he produced at least 106 covers for the sporting magazine.

1904	August	Indians and snake dance
1908	December	Whitetail deer
1924	May	Bass fishing in rowboat
	June	Camping, fishing trip
1925	October	Bluebills
	December	Bobwhite quail hunting
1926	January	Canada geese
	September	Rail shooting
	October	Hunter, lion, native (see also January 1936)
1927	January	Mallards
	November	Dog and pheasant
1928	January	Redheads
	March	Leopard with hunters
	August	Dog and prairie chickens
	September	Lion and hunter with native
	November	Hunters with elephant
	December	Canvasbacks
1929	March	Deep sea fishing
	July	Tiger and dead cow
	October	Bluebills
	November	Hunter and dog with turkeys
1930	March	Trout fisherman
	August	Fisherman and swordfish
	October	Bluebills
1931	January	Bobwhite quail with hunter and dog
	March	English and Irish setters
	July	Leopard
	August	Bass fishing in motorboat

	September	Bighorn sheep
	October	Green-winged teal and black ducks
1932	January	Mallards
	March	Deep sea fishing in motorboat
	July	Pike fishing in motorboat
	November	English setter with grouse
	December	Redheads, hunters and snowstorm
1933	January	Mallards
	March	Saltwater fishing
	September	English setters pointing quail
	October	Mallards
	December	Bluebills
1934	January	Boat with hunters in canoe
	March	Salt water fishing
	October	Green-winged teal coming in
	December	Quail with hunter and dog
1935	January	Redheads
	March	Hungarian partridge, dog, hunter
	September	Whitetail deer
	October	Grouse with hunter and dog
	December	Pintails leaving
1936	January	Hunter, lion, native (see also October 1926)
	February	Canvasbacks
	March	Saltwater fishing
	August	Tiger
	October	Mallards
	November	Grouse with hunter
	December	Bluebills
1937	January	Canada geese
	February	Bobwhite quail with hunter and dog
	September	Pheasant with hunter and dog
	October	Woodcock with hunter and dog
	November	Black ducks
	December	Bluebills

1938	February	Bobwhite quail with hunter and dog
	October	Mallards
	November	Turkey with hunter
	December	Elephant with hunters and native
1939	January	Goldeneyes
	February	Chesapeake retrieving duck
	November	Blue-winged teal
	December	Grouse, hunter, dog
1940	January	Widgeons
	February	Pointer and quail
	November	Bluebills
	December	English setter with pheasants
1941	January	Hunters with pintails, decoys
	February	Setter, pointer with quail
	September	Springer spaniel retrieving pheasant
	December	Hunter with bluebills
1942	January	Bobwhite quail with hunter and dog
	February	Saltwater fishing
	May	Bass fishing in motorboat
	September	Saltwater fishing
	December	Chesapeake retrieving mallard
1943	February	English setters with quail and hunter
	May	Tarpon fishing in motorboat
	October	Springer spaniel with grouse, woodcock and hunter
1944	June	Bass fishing in motorboat
	July	U.S. Savings Bond
	December	Whitetail deer
1945	May	Trout fishing
	August	Striped bass fishing
	November	Hunter and pheasant
1946	February	Saltwater fishing
	June	Bass fishing
	October	Pheasant hunting

1947	February	Bobwhite quail with hunter and dog
	June	Bass fishing in motorboat
	October	Mallards coming in
	December	Whitetail deer
1949	January	Canada geese coming in
1951	October	Mallards

Forest and Stream

1912	January 6	Hunters in boat flushing black ducks
1913	October 13	Hunters in boat flushing black ducks
1914	July 11	Panther lying down
	October 31	Hunters in boat flushing black ducks
1924	January	Bluebills
	September	Pintails and black ducks
	November	Turkeys
	December	Bobwhite quail

Garden Magazine

| 1921 | July | Macaw with flowers |
| | August | Wood ducks swimming |

Hunter Trapper Trader

1926	June	Canada goose and mink
	July	Fisherman and skunk
	September	Hunter and ducks and dog
	October	Bobcat and wolf
	November	Bear and hunter
	December	Turkey and owl

IO Triumphe (Albion College Alumni Magazine)

| 1939 | November | Green-winged teal |

Leslie's

1917	May 24	Eagle attacking another eagle
	October 20	American soldiers from five wars
	November 24	(copy not seen)

Liberty

1938	March 28	Hooked billfish jumping with boat in background

McClure's

1924	January	Hooked billfish jumping with boat in background

Natural History

1927	Nov.–Dec.	Pair of lions
1934	Mar.–Apr.	Elephant
	December	Shepherd with sheep
1935	January	Penguins view airplane overhead

New York Herald Tribune (Sunday supplement magazine)

1942	September 27	Pair of mallards lifting off

Outdoor Life

1929	February	Tiger and hunter
1934	January	Back page, tiger and hunter

Outdoor Recreation

(*Outer's Recreation* changed name with issue of August, 1924. Later merged with *Outdoor Life* effective with issue of September, 1927.)

1925	May	Fisherman has fish broadside in current—motions to friend for help
	September	Two setters find covey of quail
1926	February	Hooked sailfish jumping at back of boat
	March	Mountain lion and dogs
	May	Bass fishing
	June	Trout fishing in rowboat
1927	June	Muskie fishing in canoe

Outer's Book

1915	October	Back page (same as 1917)

Outer's Recreation

1922	April	Trout fishing
	May	Saltwater fishing
	June	Bass fishing in rowboat
	August	Muskie fishing in rowboat
	September	Hunter, setter and quail
	October	Hunter and Canada geese
1923	April	Trout fishing in river
	May	Bass fishing in pond
	June	Bass fishing in rowboat
	September	Hunter, shorebirds and decoys
	October	Duck hunting in boat with Irish water spaniel

Outing

1904	June	Two commercial ocean fishermen
1905	October	Three snipe in flight

People's Popular Monthly

1922	June	Puppies, kitten, boy, ice cream mixer

Pictorial Review

1924	May	Three swallows resting on branch

Printer's Ink

1934	November	Canada geese taking off

Recreation

1905	May	Group of Canada geese
1912	May	Quail

Rod and Gun Editors Association

1947	Jumping billfish with self portrait insert

Rod and Gun in Canada

1915	September	Back cover
	July	Inside cover
	August	Inside back cover
1920	August	Back ad duck shooting
1921	April	Back cover
1934	September	Flying Canada geese, hunter

Rotarian

1933	October	Mallards in flight
1935	November	Pair of Irish setters
1936	October	Quail in flight
	November	Pair of English setters
1938	October	Mallards landing with hunters in blind
1940	May	Billfish with fishing boat in background
	October	English pointer
	November	Deer
1943	November	Canada geese taking off
1944	November	Pair of English setters
1945	November	Turkeys
1946	April	Jumping billfish with fishing boat in background
1947	November	Standing elk
1948	November	Three mallards coming in
(Date unknown)		Mallards landing

Saturday Evening Post

| 1932 | March 19 | Lions |
| | August 13 | Black Panther |

Shooting & Fishing

| 1905 | December 14 | Christmas issue, cowboy and hounds |

Shooting Times

| 1962 | June | King Buck (John Olin's dog) |

Short Stories

Year Unknown October 10 Moose with hunters in canoe

Sports Afield

July 1897 Although this issue does not have an LBH cover, it is of great significance in that it contains an article entitled "A King of Game Birds" by Lynn Bogue Hunt written from a return address of Albion, Michigan. In addition, the article is accompanied by a drawing of a grouse which is signed "Lynn B. Hunt" in script. This may be Hunt's first drawing and article published in a national sporting magazine. Lynn B. Hunt was 19 years old during 1897 and enrolled in Albion College as a freshman during the fall of 1897. This same illustration was used by *Sports Afield* in its advertising over the next several years.

1900 Hunt's first cover appeared on the cover of *Sports Afield* in 1900. The large number of L. B. Hunt illustrations which begin to appear in *Sports Afield* during the early 1900s suggest that either he went to work for them full-time or that he was unusually successful in submitting his artwork for publication. It should be noted that, in contrast with most of his career as an illustrator, while at *Sports Afield* he signed his work simply L. Hunt. At least 59 covers (many repeats) by Lynn Bogue Hunt appeared on *Sports Afield* between 1900 and 1908.

 August Trout fishing on the Nipigon River. (This appears to be the first L. B. Hunt sporting magazine cover.)

	November	Heron masthead and design with photograph insert. Although this version is not signed by L. B. Hunt, it is the same heron masthead which appeared in March of 1901 and is signed by L.B.H. This same cover design appeared a total of at least 12 times on the cover of *Sports Afield*.
	December	Indian hunter carrying wild turkey
1901	January	Heron masthead and design with photograph insert
	February	
	November	
	December	
	March, April	Heron masthead with a pair of lions as sidebars
	May, June,	
	July, August	
	September	
	October	
1902	January	Standing moose
	March, July	Heron masthead and design with photograph insert (Same cover as used in 1900 and 1901)
	August	
	September	
	October	
	November	
	December	
1903	January	Fox chasing grouse
	March	Geese in flight
	April	Heron watching for fish
	June, July	Antelope
	August	
	September	
	October	
	November	
	December	

1904	January	Antelope
	February, May	
	June, July	
	September	
	October	
	November	
	December	
	March	Geese in flight (Same cover used in April 1903)
	April	Heron watching for fish
	August	Heron masthead and design with photograph insert (Same cover used in previous years)
	December	Indian hunter carrying wild turkey (Same cover used in previous years)
1905	January	Antelope (Same cover used in previous years)
	February	
	March	Geese in flight (Same cover as previous, unsigned, probably LBH cover)
	April	Heron watching for fish (Same cover used in previous years)
	October	Cowboy on horse (Unsigned, probably LBH cover)
1906	January	Standing moose
	March	Geese in flight (Same cover as previous, unsigned, probably LBH cover)
	April	Heron watching for fish (Same cover used in previous years)
	December	Indian hunter carrying wild turkey (Same cover used in previous years)
1907	January	Standing moose (Same cover used in January 1902)
	March	Geese in flight (Same cover as previous, unsigned, probably LBH cover)

	December	Indian hunter carrying wild turkey (Same cover used in previous years)
1908	March	Geese in flight (Same cover as previous, un-signed, probably LBH cover)
1918	December	Indian hunter carrying wild turkey (Same cover used in previous years)
1919	December	Indian hunter carrying wild turkey (Same cover used in previous years)

The Spur

| 1935? | August | Billfish jumping with fishing boat in background |

Woman's Home Companion

| 1932 | September | Cat and three kittens |

Yachting

| 1935 | April | Billfish jumping in back of sportfishing boat |

CATALOG COVERS

L.L. Bean Catalog Covers

1936	Fall	Setter with bird in mouth
1937	Fall	Setter with bird in mouth
1942	Fall	Setter with bird in mouth (same cover as others, not signed)
1950	Fall	Canada geese landing

Ithaca Gun Company

191?	Fox chasing pheasant	16 pages (pocket)
1916	Fox chasing turkey	24 pages 13¾" × 8¼"
1919	Fox chasing pheasant	8 pages 6¼" × 3½"
1919	Fox chasing pheasant	30 pages 13¾" × 8¼"
c. 1928–30	Fox chasing pheasant	(pocket)
?	Fox with slain rabbit being harassed by crows	(pocket)

Von Lengerke & Detmold camping catalog

Six gamebird images on cover 290 pages

L. B. Hunt Glassware, tile, coasters and plates

L. B. Hunt decorated various glasses with both gamebird and racing horse images. The same images appear on several versions of plates, ashtrays and coasters.

Gamebird Glasses by Federal Glass Co.

Jumping pintails

Mallards climbing out

Broadbills decoying

Pheasants getting out

Canvasbacks flaring out

Ruffed grouse rising

Horse Glasses

Count Fleet

Gallant Fox

Man O'War

Seabiscuit

Twenty Grand

Whirlaway

Gamebird Plates

Pheasant

Canada Goose

Horse Plates

Seabiscuit

Man O'War

Tile Coasters

Count Fleet

Gallant Fox

Man O'War

Seabiscuit

Twenty Grand
Whirlaway

L. B. Hunt Advertising Art and Related Material

Work by L. B. Hunt appeared on a great variety of posters, calendars, catalogues and magazine ads for many companies, including the following:

DuPont Powder Co.	Remington Arms Co.
Hercules Powder Co.	Union Metallic Cartridge Co.
Selby Smelting and Lead Co.	Western Cartridge Co.
Peters Cartridge Co.	Winchester Repeating Arms Co.

Many of these works are highly desirable sporting collectibles and many have been further described and illustrated in various collector's guides and books. Detailed descriptions of these reference volumes follow below:

John Delph, "Firearms and Tackle Memorabilia, A Collector's Guide," Schiffer Publishing Co., Westchester, Pa., 1991, 144 pp., 8½" × 11." This book includes hundreds of color photos and a price guide. In addition to L. B. Hunt's work, it includes work of many of the popular outdoor artists. The most comprehensive and authoritative book on the subject.

Russ Mascieri, "Victorian Images Auction Catalog," Marlton, NJ, 1993–1995, various dates, 8½" × 11", pb.

Bob Strauss and Beveraly Strauss, "American Sporting Advertising," Vol. 1, Circus Promotions Co., Jefferson, ME (Paulsons Litho Inc., Palatine, IL), 1987, 8½" × 11", not paginated, pb. This book contains black and white pictures of sporting collectibles, posters and calendars. An accompanying price guide has been updated to 1992.

Bob Strauss and Beveraly Strauss, "American Sporting Advertising," Vol. 2, Circus Promotions Co., Jefferson, ME (Camden Printing, Camden, ME), 1990, 8½" × 11", not paginated, pb. Contains black and white pictures of hunting and fishing posters, calendars, cartridge boards and a 1990 price guide.

Calendars and Posters by L. B. Hunt
Dimensions in inches

DuPont Powder Co.

Date	Format	Topic	Reference	Image Size	Overall Size
1902	Calendar	Woodcock ? (unsigned)	S I/DP-04	13¾ × 28¼	13¾ × 28¼
1909	Poster	"Get Your Shot Out There"	S I/DP-23	14½ × 20¼	17 × 25¼
1909	Poster	"The Dense Powder for Shotguns"	S I/DP-36	20 × 25½	20 × 25½
1912	Poster	"Look Who's Here"	S I/DP-34	18 × 18	20 × 25
1912	Poster	"Broadbills Here They Come"	S I/DP-22	14¾ × 20¼	17¾ × 27
1913	Poster	Quail family	S I/DP-29	20 × 20⅛	21 × 29¾
1917c.	Poster	"Shoot DuPont Powders"	S I/DP-30	N/A	N/A
1917	Poster	"Our American Birds"- portfolio	13 × 14½	10 × 11	
1962	Calendar	Male and female pheasants	L-S-#19-95	10 × 11	14 × 30
ND	Poster	Ducks coming in (unsigned)	S II/DP-38	18 × 12	18 × 12

Hercules Powder Co.

Date	Format	Topic	Reference	Image Size	Overall
1914	Calendar	"The Game Bird of the Future"	S I/HE-01	17⅞ × 16	19¾ × 30
1914c.	Poster	"The Game Bird of the Future"	S I/HE4-48	18 × 16	18 × 20⅛
1915	Calendar	"Black-breasted plover"(unsigned)	S I/HE-03	12 × 19⅝	12½ × 27⅛
1915	Poster	"Black-breasted plover"(unsigned)	S I/HE-58	12 × 19¾	15 × 26½

Peters Cartridge Co.

Date	Format	Topic	Reference	Image Size	Overall
1914	Calendar	Setter flushing mallard	S I/PC-13	13¾ × 27	13¾ × 27
1929	Calendar	Mallards in flight	S I/PC-28	15 × 18	15 × 27¼
1931	Calendar	Pair of pheasants	S I/PC-30	12 × 21½	13⅝ × 32 ⅛
ND	Poster	"Peters Packs the Power"	S I/PC-52	17 × 20½	24 × 35¾

Pflueger Fishing Tackle Co.

Date	Format	Topic	Reference	Image Size	Overall
ND	Die-Cut	Two men in boat	L-S-#98-96	N/A	17 × 22

Remington Arms Co.

Date	Format	Topic	Reference	Image Size	Overall
1906	Die-Cut	Moose, bear, wolf and rabbit	L-S-#441-93	N/A	N/A
1917	Calendar	Setter flushing quail	S I/RA-06	14 × 18¾	15 × 30¾
1919	Calendar	Eagle attacking geese	S I/RA-08	14 × 18¾	15 × 30¾
1921	Calendar	Fox spooking geese	S I/RA-10	13¾ × 18¾	15 × 29
1923	Poster	Remington Game Load Game	L-S-#069-04	N/A	18 × 26
1929	Poster	A Tribute to a Dog	S I/RA-32	12 × 21½	13⅝ × 32⅛
ND	Poster	Remington Game Load Game	S I/RA-29	16⅛ × 22¼	18½ × 26
ND	Poster	Mallards landing	S II/RA-46	15¾ × 23	18 × 24¼
ND	Poster	Recommended Game and Trap Loads	S II/RA-50	20 × 26⅛	20 × 26⅛
ND	Die-cut	Remington Game Loads	VI94/55	21 × 36	
ND	Die-Cut	Grouse with game load box	D p.56	10½ × 10½	10½ × 10½

Savage Stevens

Date	Format	Topic	Reference	Image Size	Overall
Unknown	Stand-Up	Woodchuck sitting on ground	VI#187-1993	14 × 25	14 × 25

Selby Smelting and Lead Co.

Date	Format	Topic	Reference	Image Size	Overall
1917	Calendar	Duck hunter with decoys in boat	S II/SB-03	15¾ × 25¼	16¼ × 26½

Union Metallic Co.

Date	Format	Topic	Reference	Image Size	Overall
1907	Poster	Blue-winged teal	S I/UM-24	11½ × 33½	12 × 34
1908	Poster	Quail landing (unsigned)	S I/UM-25	15 × 29¼	15 × 29¼

Western Cartridge Co.

Date	Format	Topic	Reference	Image Size	Overall
1928	Calendar	Snow geese in flight	S I/WE-09	12¼ × 17¼	14½ × 28
ND	Poster	Bobwhite	S I/WE-22	14½ × 23	15½ × 24¼

Winchester Repeating Arms Co.

Date	Format	Topic	Reference	Image Size	Overall
1915	Calendar	Eagle attacking mountain sheep	S I/WR-19	13¾ × 20	15¼ × 30¼
1929	Calendar	Hunter and dog flushing pheasant	S I/WR-33	13½ × 18⅛	15 × 26⅛
ND	Poster	When Calls the Lure . . .	S I/WR-87	20¼ × 15¼	20¼ × 15¼
ND	Die-Cut	Ranger, The New Smokeless SHOTSHELL	S II/WR-103	10 × 15	10 × 15

Reference Code: SI and SII (Strauss Vol I and II); D (Delph); VI (Victorian Images)

Note: During the process of compiling this list, it is likely that errors of omission have occurred. Hunt may have illustrated additional covers of *Boy's Life*, *Colliers*, *Country Gentleman*, *Delineator*, *Literary Digest*, *Natural History*, *The Garden Magazine*, and *Yachting*.

If a reader of this listing is aware of other works by L. B. Hunt, I would appreciate corrections or additions being brought to my attention.

Kevin C. Shelly

E-mail: KCShlly@aol.com

My thanks to Lou Razek, Paul Vartanian and Ann Farley Gaines in assembling this list.

Index